W9-CSP-823

Peaceful Painter MEMOIRS OF AN ISSEI WOMAN ARTIST

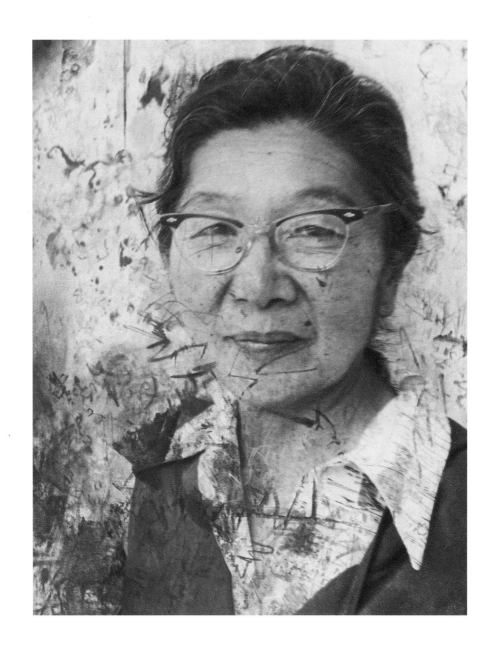

Peaceful Painter

MEMOIRS OF AN ISSEI WOMAN ARTIST

HISAKO HIBI (1907–1991)

Heyday Books, Berkeley, California

Hisako Hibi asked that her book be dedicated
to the Issei mothers of the United States

© 2004 by Ibuki H. Lee

All rights reserved. No portion of this work may be repro-
duced or transmitted in any form or by any means, elec-
tronic or mechanical, including photocopying and record-
ing, or by any information storage or retrieval system,
without permission in writing from Heyday Books.

Library of Congress Cataloging-in-Publication Data

Hibi, Hisako, 1907-1991.
 Peaceful painter : memoirs of an issei woman artist /
Hisako Hibi, Ibuki H. Lee.
 p. cm.
 Includes bibliographical references.
 ISBN 1-890771-90-2 (pbk. : alk. paper)
 1. Hibi, Hisako, 1907-1991. 2. Japanese American
painters--Biography. 3. Painters--United States--
Biography. 4. Japanese Americans--Evacuation and reloca-
tion, 1942-1945. I. Lee, Ibuki H. (Ibuki Hibi) II. Title.
 ND237.H5744A2 2004
 750'.89'956073--dc22

 2004007649

Book design by Rebecca LeGates
On the cover: *Homage to Mary Cassatt* by Hisako
Hibi,1943, 24 x 20 in., oil on canvas, Topaz, Utah. Family
collection.

Page ii: Hisako Hibi portrait with transposed painting,
1976, San Francisco, CA. Photo by Stefanie Steinberg.

Orders, inquiries, and correspondence should be addressed to:
 Heyday Books
 P.O. Box 9145, Berkeley, CA 94709
 (510) 549-3564, fax (510) 549-1889
 www. heydaybooks.com

Printed in China by Imago

10 9 8 7 6 5 4 3 2 1

Contents

Foreword

REBECCA M. SCHAPP, Director, de Saisset Museum

KAREN KIENZLE, Curator of Exhibits and Collections

The de Saisset Museum at Santa Clara University is proud to present the exhibition *The Art of Hisako Hibi* in conjunction with the publication of this memoir. Like her paintings, Hisako Hibi's memoir is deeply personal but also holds universal significance.

In the words and images of Hisako Hibi, we witness the struggles and celebrations of family, motherhood, and career. However, as this memoir and the exhibition illustrate, many of Hibi's personal and professional experiences unfolded against the backdrop of the Japanese American internment camps. Because of this, Hibi's art and writings serve as powerful reminders of this tragic period in history, as well as compelling educational tools. And Hibi's images and memoir ultimately exemplify the triumph of art over adversity. Like other accomplished artists throughout history, Hisako Hibi used her art as a tool to document and to understand her world and her experiences throughout her life.

Santa Clara University is dedicated to educating the whole person for a life of service and leadership and has demonstrated for 152 years a dedication to educating students for competence, conscience, and compassion. We value the opportunity to collaborate with the Japanese American National Museum in the presentation of this exhibition. We are also greatly appreciative of the generosity of Mamoru and Yasuko Inouye, who provided the support to make the exhibition a reality.

Over its fifty-year history, the de Saisset Museum has committed itself to showcasing exhibitions that both highlight the diversity of the region and address the issues of contemporary society. We are delighted to continue this tradition by presenting Hisako Hibi's work to both the Santa Clara University community and the community at large.

Introduction

KRISTINE KIM

I first encountered the art of Hisako Hibi (1907–1991) in 1994 at the San Jose Museum of Art, where several of her paintings were shown as part of the traveling exhibition *The View from Within: Japanese American Art from the Internment Camps, 1942–1945,* organized by the Japanese American National Museum. As a student of art history, I was particularly struck by Hibi's *Homage to Mary Cassatt.* Up until that point I had barely known of any Japanese American artists practicing in the 1940s. I had certainly never imagined that among them would be an immigrant woman so well versed in the vocabulary of western oil painting that she could masterfully adapt a famous Cassatt painting into a work so uniquely her own, so deeply moving, and with such historical substance. In the last ten years I have learned that it is characteristic of Hibi's life and art to unfold in such surprising ways, and I realize that the more I learn, the more complex her story becomes.

Beginning in the late 1970s and into the 1980s, the Japanese American community began, for the first time, to discuss in public their wartime incarceration and, most significantly, to label it as unconstitutional and unjust. Hisako Hibi and many others who had depicted their wartime experiences in their art played an important role in the community's ability to come to terms with this experience. It was at this time that Hibi became known as an artist of the camps. Exhibitions and displays of artwork, some of which had never before been publicly shown, sparked people to recall memories long buried. This focus on remembering and bearing witness to the incarceration itself meant that art like Hibi's—illustrating what many could not even imagine—was looked to for its documentary nature.

Even at the time they were in the camps, Hibi and many other professional artists realized to some degree the extraordinary nature of what they could accomplish in those circumstances. With the strict ban on cameras, painters especially used their skills to record their experiences for the sake of history. And the time spent in the imposed solitude of the camps ironically became an incredibly prolific period for artists who otherwise could not have afforded to dedicate so much time to their art.

The works of art that have survived the decades since the closing of the camps reveal many landscapes and scenes of daily life: rows upon rows of barracks, imposing guard towers, and barbed wire fences are frequently depicted, and long lines for the mess hall and showers are also common subjects. While different artists often used similar subjects and motifs in their work, it is clear that each offered his or her own interpretation and perspective, and Hibi was no different in this regard. She created approximately seventy oil paintings and numerous sketches during her incarceration at what were officially named the Tanforan Assembly Center, in the San Francisco Bay Area, and Topaz Relocation Center, in Utah. Hibi's work offers not only scenes of daily life, but a sense of the duration of time spent behind barbed wire. She and her family lived in the camps for three and a half years, and through Hibi's paintings we witness the passing of the seasons, from the summertime harvest of vegetables grown by inmates to supplement their government-issued rations, to the harsh Utah winters that blanketed the camp in snow, to the blossoms that heralded springtime.

Perhaps what distinguishes Hibi most significantly from other Japanese American artists of the camps is that she was a woman and a mother; by far the majority of painters were men, and none of the other women painters that we know of had children. Some of Hibi's strongest paintings show camp life from a mother's point of view. *Homage to Mary Cassatt* depicts an affectionate moment between a mother and daughter, although the context of the camps is referenced with the inclusion of the pot-bellied stove in the background. The work is fashioned after *The Bath* (1892) by Mary Cassatt, herself a pioneering woman artist whose decision to present images of the domestic realm of women and children was considered radical at the turn of the twentieth century.

The notion of painting domestic scenes in the context of the camps is also intriguing in light of the institutionalized lifestyle imposed on inmates. Meals were served cafeteria-style, for example, so that families rarely ate together. Wives and mothers could not cook for their families, and many of their otherwise typical household duties were rendered unnecessary or impossible by one-room living quarters and communal bathrooms. Hibi's *Laundry Room* provides a unique glimpse into the resourcefulness of mothers who bypassed long lines to the

showers and used the laundry facilities to bathe their young children instead.

Hibi's camp work is not limited to domestic scenes. In fact, she stands out as someone who experimented a great deal with style and subject matter during the war. In addition to many starkly beautiful landscapes, she created notable portraits and several still life paintings. Among the most interesting is *Topaz Farm Products,* in which she evokes the bounty enjoyed by inmates thanks to the efforts of those who turned the arid desert into farmable land. In *New Year's Mochi,* painted in 1943, Hibi uses her art as a means of cultural survival. Although she could not engage in the tradition of making, displaying, and enjoying *mochi* (sweet rice cakes) in celebration of the new year, she could paint an image to overcome the physical boundaries of her confinement.

The combination of skilled artists with hundreds of inmates forced into idleness led to a flourishing of arts and crafts in the camps. At Tanforan and Topaz in particular, the art school became an important way to channel the energies of many of the more than eight thousand inmates.

Under the guidance of artist and professor Chiura Obata (1885–1975), an art school was established at Tanforan within the first few weeks of incarceration. The school re-established itself at Topaz concentration camp, where it grew to accommodate approximately eight hundred students. Believing in the power of art to transform people and help them to transcend, even temporarily, the camp environment, Hisako Hibi taught the children's classes in drawing and painting. Her husband, George Matsusaburo Hibi, took over the leadership of the school in 1943 when Obata obtained permission to leave Topaz.

Topaz had the largest concentration of professional artists of all the camps, providing the art school with a talented and experienced pool of teachers. Besides Chiura Obata and the Hibis, other artists at Topaz included Miné Okubo (1912–2001) and Byron Takashi Tsuzuki (1901–1967). All of these artists had different training and areas of expertise, and their work represented a range of styles and philosophies. The goal of the school was not necessarily to train students to practice a particular style or to be professionals. In fact, the school took a broad view of the arts and aimed to engage inmates in many forms of creative expression. With students ranging in age from five to eighty years old, the curriculum had to be broad and flexible. There were courses in drawing, painting, anatomy, and art history, as well as tailoring, crochet, *ikebana,* and many other art forms. All courses could accommodate those with previous experience and those with none at all. The school's philosophy, as written by George Matsusaburo Hibi, was that "Training in art maintains high ideals among our people, for its object is to prevent their minds from remaining on the plains, to

encourage human spirits to dwell high above the mountains."

Had it not been for the movement to collectively remember and reckon with a painful past, many people might never have learned about Hisako Hibi's remarkable work. The recognition she received, beginning in the 1970s, for her camp paintings was extremely important in establishing her as a significant artist in the Japanese American community—so much so that her wartime paintings came close to overshadowing her artistic accomplishments that preceded and followed World War II.

The least known and understood part of Hibi's life and career is the prewar era. For most Japanese Americans this is true, in large part because of the war and the destruction or loss of personal possessions. For artists, the issue of storing or finding homes for their artwork proved daunting. George Matsusaburo Hibi donated fifty paintings to the city of Hayward just prior to the forced removal, with the idea that the paintings would be placed in responsible government hands. These works have never been recovered.

What little is known about Hisako Hibi's life in America prior to World War II is telling, in light of all she subsequently overcame and accomplished. She arrived in Seattle in 1920 with her parents, but in 1925 made a bold and highly unusual decision. That year her parents returned to Japan, while Hibi,

only eighteen years old at the time, remained on her own in San Francisco. While no statistics exist to document the highly unorthodox nature of this move, suffice to say that Hibi would have been among a very small number of *Issei* (first generation in the U. S.) women who were allowed to stay in the United States without their families. Single women in general were not often allowed to live on their own at the time, and fewer still had the opportunity to pursue art as a career.

In 1926 Hibi enrolled at the California School of Fine Arts. She studied with noted artist Gottardo Piazzoni and was thoroughly engrossed by her work. Perhaps more important than what she studied in her coursework was the fact that Hibi found herself in a highly dynamic milieu of artists who came from all over the nation and the world. This exposure to many different people and ideas certainly must have impressed her as a young woman.

Among the artists she met through her classes was George Matsusaburo Hibi. While she had already forged an unconventional path for herself, she ultimately decided to accept his proposal of marriage, knowing that as a fellow artist he would support her creative endeavors.

Hibi was perhaps unconventional, but she was by no means radical in her decisions. She chose to stay in the United States on her own, but she still married and had a family. Her belief in the injustice of the incarceration never wavered, yet her paintings of the camps are

more poignant than bitter. Throughout her life, Hibi would confront the conflict between, on one hand, her desire for the freedom to make her art and, on the other, the expectations and constraints placed on someone of her race, gender, and economic status. Hibi's resilience in the face of these hardships suggests the magnitude of her determination.

In 1999, I met Hibi's daughter, Ibuki, for the first time. In what appeared to be a modest-sized San Francisco apartment, I viewed an unbelievable number of paintings and sketches kept lovingly by Ibuki since her mother's death in 1991. Even more than the number of paintings, the range of subjects and styles in the works themselves, which dated from the 1950s, bewildered me. Had I seen these separate from the camp paintings, I would never have guessed them to be by the same artist.

Hisako Hibi and her family left Topaz and moved to New York City in 1945. The tragic passing of her husband less than two years later left her with the sole responsibility for her two children. The stress of the situation is hard to imagine, but clearly Hibi managed to survive, and most significantly, to continue to paint. She even attended classes with Victor D'Amico at the Museum of Modern Art. The decision to be a painter was not an easy one for any woman of Hibi's generation, much less an immigrant and single mother.

Hibi's paintings from this period stand in stark contrast to her camp work. While the paintings of Tanforan and Topaz have a somber undertone, they also have a sense of composure. Life in the camps may not have been easy or enjoyable, but Hibi coped as best she could and sought beauty in the landscape or in the tenderness of everyday life. The New York paintings, on the other hand, are marked by a stormy energy with unsettling swirls of black. The canvases from the 1950s clearly attest to how Hibi was influenced by the movement toward abstract painting. Her palette is much more vibrant than in camp, perhaps owing to the greater availability of materials in New York, but also in response to the palette of the city itself.

In 1954 Hibi's son, Satoshi (Tommy), had joined the military, and she and her daughter left New York for San Francisco, carrying with them the many paintings she and her husband had painted during the incarceration and after. In 1962, Hibi donated her husband's work to the Japanese American Research Project at the University of California, Los Angeles, where it is part of an important repository of items by and about Japanese Americans.

Hibi continued to work at her painting, and the canvases she began to create in the 1960s reveal her continued development toward non-representational painting. Color became much more important in her work. Ibuki pulled out dozens of these paintings on my visit in 1999. Many of them were left unstretched, and we lay them on the floor, where I crouched down to view them more closely. Hibi herself had painted

them in this manner, not on a traditional easel or even upright.

In some works I could see Japanese characters and small, recognizable images—two hands held together as if in prayer, a Buddha, a sun. Ibuki told me about her mother's intense interest in Buddhism later in life and that her paintings reflected her focus on issues of peace. The works were profoundly accomplished, and I was moved to see how Hibi had evolved and grown as an artist. It is unusual to find artists who effectively express their own voices in their work, and even more exceptional to find an artist who has two different but equally strong voices. Hibi's camp paintings are invaluable for their unique interpretation of the camp experience; her postwar paintings are highly accomplished and show both inner reflection and an eye toward universal themes.

Hibi gained recognition for these postwar paintings during her lifetime. From the 1970s on, she consistently showed in both group and one-person exhibitions in mainstream venues throughout California, and in New York as well. In 1985 the San Francisco Arts Commission gave her an Award of Honor in Painting. Though she did not necessarily receive as much critical attention as she may have deserved, it is evident that others recognized the strength of her work. In a way, Hibi had a dual identity, becoming noted within art circles for her contemporary work just as the Japanese American community discovered the historical importance of her wartime work.

It is a gift to have Hisako Hibi's memoirs and to contemplate examples of her astonishing body of work; the presentation of her entire life story with works from every time period will shed a much-needed light on this remarkable woman for whom painting was the one and only constant. Through the turmoil of the war years and subsequent struggles, she turned to her art. For Hisako Hibi, it was a means to peace.

Recollections

IBUKI HIBI LEE

I remember my mother as a thoughtful and driven individual who experienced periods of profound sadness during her lifetime. Yet she had an indomitable spirit and artistic vision that sustained her throughout her travails.

My parents were *Issei,* the pioneers of the current generations of Japanese Americans, and they were rugged individualists in their own right. With dreams of being artists in the free society of the United States, they were truly alone and isolated from their parents and extended families in Japan.

My mother would remember with nostalgia her early childhood years, spent with her stoical Zen Buddhist grandmother in Fukui-*ken* (prefecture), Japan. "She taught me right. She gave me discipline." Her *obaasan* (grandmother) also carried her lovingly on her back while visiting the countryside temples to recite her ritual sutras.

"Those were the happy years," my mother would relate to me, describing the few years before Pearl Harbor. Relatively speaking, the decade before the war was difficult, raising a family on a scant income and delaying her dream of furthering her art study. Yet she continued to paint at home and to exhibit locally, and at the time "there were the sweet sounds to be heard on the school's piano and happy children to be seen scurrying among Hayward's orchard trees."

The bombing of Pearl Harbor changed the lives of all Americans, including those of Japanese ancestry in the United States. The following years for my mother, spent in the internment camps and later in the poverty of New York City, were depressing times for her, filled with uncertainty and fear.

Struggling with outward circumstances and inner demons, she persevered—renewed her

strength, and developed her personal artistic statement and spiritual life. During the last decade of her life, she remarked, "Nothing matters anymore. I've made my peace." She felt liberated in her art and spirit.

My mother was an ordinary human being who rose above the despair of her social and economic condition and recognized the power in art to transform her life and spirit. Hisako Shimizu Hibi was a farmer's daughter of the Meiji era, an honest, hard-working wife and mother, a domestic worker and a dressmaker. She became an unusual Issei woman artist, a peaceful painter who abhorred war and suffering. I hope that you will enjoy her story.

This book would not have been possible without a California Civil Liberties Public Education Program grant and the support of many individuals, whom I mention in my Acknowledgments in the back of this book because there were so many of them. I have tried to edit the text of my mother's memoir for spelling, grammar, wording, and sentence structure while maintaining the stories and details from her life and experiences intact. My mother's artwork was a vital part of her life, and the selected paintings in this book represent her lifelong joy in painting.

Peaceful Painter
MEMOIRS OF AN ISSEI WOMAN ARTIST

HISAKO HIBI (1907–1991)

Although unbelievable today, it did happen in San Francisco, in Oakland, in towns near the beaches, in the villages between the valleys, and all along the Pacific Coast from the state of Washington down to California and to parts of Arizona in 1942. Japanese Americans were uprooted from their homes. Yesterday's friends were today's enemies. The air of alienation and hostility was felt everywhere.

"Where are we going? Why do we have to go? Is Mrs. May going with us?"

"No," he answered.

"Why?"

"Why" was a word Ibuki frequently used those days. Neither my husband nor I could provide our five-year-old daughter with satisfactory answers, because we ourselves did not know why we were forced to leave. It was a very sad time.

American Freedom

I was born on May 14, 1907, in Japan, in a small, peaceful farming village called Kochi, near Torihama in Fukui-*ken,* surrounded by green mountains and five lakes. Over the mountains was the Sea of Japan, which extends north to seaports in Russia. The first foreigner I saw was a Russian merchant seaman at Tsuruga, a port city near my hometown. I grew up in a home that actively practiced Zen Buddhism, where I was accustomed to an abundance of goods from the land and sea and was joyfully anticipating attending the girls' high school in the city. At that time very few girls were permitted to go on to high school from the village, so for that I was especially happy.

But those dreams came to an end when my father suddenly returned from America and said that my mother and I would have to go to America with him right away. He explained that

an immigration exclusion law was soon to be passed which would prevent Japanese immigration to the United States, so we must leave right away. A father had supreme authority in those days. So I knew there was no choice.

In the spring of 1920, as a country girl of fourteen (in Japanese years), I arrived in Seattle, Washington. On the night of our arrival the passenger ship burst into a huge, disastrous fire, and smoke filled the cabins. The passengers were told to jump from the deck to the spreading nets below.

The next day we were all sent to the Immigration office. My ship had many picture brides, who were married in Japan by proxy to Japanese men in America. Since marriages in Japan were arranged between families, the husband and wife did not get to know each other until after the marriage. These women who came to America to live with their husbands were called "picture brides" because they exchanged photographs with their prospective mates and would use these pictures to match themselves with their spouses upon arrival.

Many picture brides traveled across the Pacific Ocean, not out of choice or because of their ambitions, but due to certain circumstances within their families which compelled them to come over to start new lives. One bride suddenly changed her mind and decided to return to Japan on the same boat. Others became confused because their husbands looked so different from their pictures.

For unknown reasons I was not allowed to disembark with my parents, and I was held up along with the picture brides. Rumors persisted that because our ship was the last one before the exclusion law went into effect, the federal officials were being extra careful investigating all of the young women on board. As a result, I looked at America for the first time through the iron-barred windows of a large, ward-like room filled with the young women. Everyone cried, so I cried too. The turmoil, confusion, and uncertainty made us unable to sleep most nights. No one was accustomed to bunk beds, and when someone fell off their bed, it added more general excitement to the situation.

As the days went by, packages started arriving, as well as visits from the husbands themselves. Inside the bundles were blouses with white lace collars, feathered hats, skirts, shoes, big black leather purses, necklaces, shining pins, gloves, and so many other presents. My mother bought me a lacy, white dress, a straw hat, and a stylish pair of long, button-on brown shoes. These shoes were so tight that I have not liked to wear shoes ever since.

Two weeks after arriving in Seattle, I was able to walk out of the Immigration building. I put on my new white dress and buttoned up the front. It was tight and uncomfortable. As I was walking down the street breathing the fresh air, a Caucasian woman came by and started to talk to me with her hands, words and gestures. I thought that I had done something wrong. My

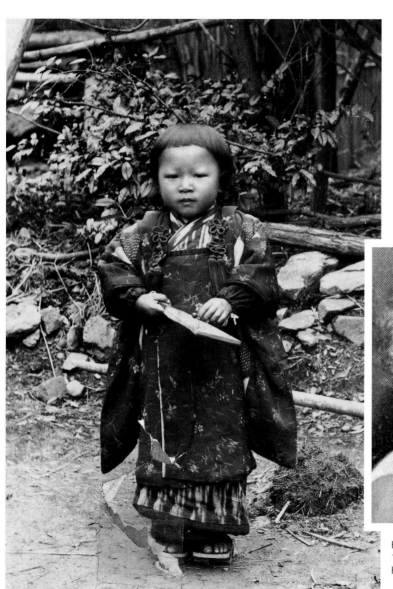

Hisako Shimizu, circa 1910,
Fukui-ken, Japan. Family collection.

Hisako "Mary" Shimizu, December
1929, San Francisco, California. Lowell
High School yearbook photo.

father understood a few words of English, but my mother and I stood speechless. It turned out that my dress was on backwards, and she was kind enough to try to explain this to us. My mother said afterwards that she would never think of a kimono that would (unlike a dress) open in the back.

On the way from Seattle to Los Angeles, which was our final destination, my father stopped at a farm near Sacramento where young Japanese men were picking plums. There were so many plums that the men bent the branches in an arch almost touching the ground. In the wide, open spaces there was a Japanese-style round bathtub, where a snake was crawling at the edges. A young mother, carrying a baby on her back, was pumping water from the well into a bucket. She walked back and forth, filling the tubs for the after-work evening baths of the laborers.

Near Fresno there was a wide stretch of strawberry fields. There too were young Japanese mothers, carrying babies on their backs or in buggies, working alongside their husbands out in the fields. The *Issei* (first generation) mothers used their hands and their whole bodies for their families and tried to improve their situation, since they were destined to make a living in America.

The immigrant society in America in 1920 was not a pleasant place for a teenager like myself, for I did not meet any young Japanese girls of my age. Once in a while the *Do-ken-jinkai,* whose members came from the same prefecture in Japan, would get together to socialize, but they were mostly young men and picture brides, and all they talked about were money matters, jobs, and their homeland.

When I started school, I was put into the second grade for reading and writing and into the sixth grade for arithmetic. Someone started calling me "Mary." They said that it was easier to say than "Hisako." Now, when I think of those days, I remember that I did not know how to talk with teachers and my classmates. I could only accept their orders.

Later, in the summer of 1926, I entered the California School of Fine Arts, now the San Francisco Art Institute, to study the western style of oil painting. It was a great joy and it was exciting to carry a paint box for the first time. We took a ferryboat to Sausalito and then transferred to a train to Larkspur and to Kentfield to draw landscapes with our teacher, the late Gottardo Piazzoni, now a famed San Francisco artist. He led the class in landscape painting in Marin County. Up and down the hills and groves, over acres of green pastures with cows, white houses, and barns we painted. Sometimes the wind blew our canvases to the ground. On our return ferry trip we had, for only five cents, a leisurely cup of coffee and a donut, which tasted so good.

I met Matsusaburo Hibi at the art school, and we were married in 1930. In 1932 we moved to Mt. Eden and later to Hayward,

where he established the Hibi-*juku,* teaching Japanese language and art classes. The exclusionists pointed to the teaching of the Japanese language to American-born Japanese children as proof of the disloyalty of the Japanese in America. However, during World War II, those young men who understood the Japanese language performed an invaluable service to this country in the Pacific, as part of the MIS, the Military Intelligence Service of the United States.

Hometown: Hayward, California

The house was a happy one with my husband and our two children, Satoshi "Tommy" and Ibuki "Peek-a-boo." We lived in a little town near San Francisco, and our home had an apricot orchard on one side and a wide stretch of tomato fields on the other. The backyard was large enough for playing ball, cultivating a vegetable garden, and raising chickens. Five brown hens and a rooster clucked and busily scratched for food on the ground. The two children chased them and ran to pick up the eggs while loud cackles echoed through the air. The wind blew through an old walnut tree standing beside the house, shaking the bevies of chirping sparrows in the branches. Nearby in the pond, colorful goldfish swam peacefully.

Matsusaburo planted a few bamboo and *yamabuki.* Bamboo is famous in Chinese and Japanese *sumie,* brush painting. The yellow, flowering *yamabuki* is likewise famous in poetry.

A friend planted two peach trees. The light pink-flowered one bloomed during *Momo-no-sekku (Hinamatsuri),* the girls' Doll Festival, on March third, and the darker pink one opened its blossoms around *Tango-no-sekku,* Boys' Day, on May fifth, when families display colorful carp fish kites outside their homes. The plants grew well here—our new land.

Our family had many friends in the community, among them Mrs. Elsie May. Tommy made her a cute birdcage, which she hung on an old oak tree in her yard. One day Matsusaburo and Ibuki, then three years old, visited Mrs. May. While they were talking in the garden, Ibuki ran behind the bushes, poking her head in and out. Each time Mrs. May caught sight of her bright face, she said, "Peek-a-boo!" That was when Ibuki named herself "Peek-a-boo," and the two became good friends, spending many hours together walking, talking, and singing in the garden.

Matsusaburo was an artist and a Japanese language teacher. As an artist, he taught the interaction between line, color, and form to express his experiences in paintings and in woodblock prints. As a Japanese teacher, he tried to have his students understand the differences between the two cultures. For one, English is written from the left to the right, horizontally. Japanese is read from the right side, top to bottom, vertically, so that the last page of an English book is the first page of a Japanese one.

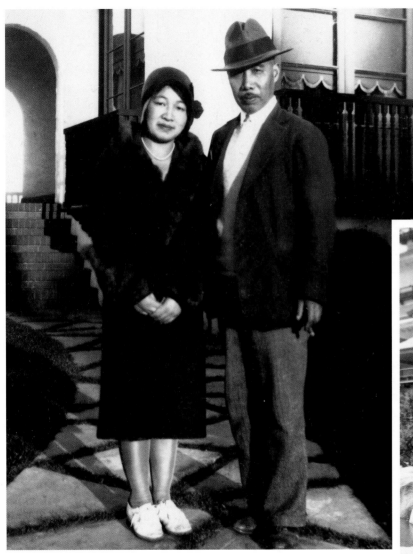

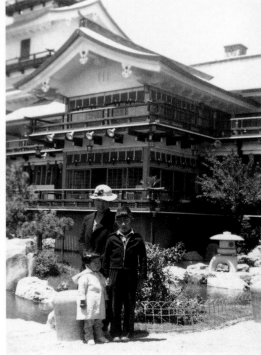

Matsusaburo and Hisako Hibi,
1931, San Francisco, California.
Family collection.

Hisako, Satoshi "Tommy," and Ibuki
Hibi at the Japan Pavilion at
1939–40 World's Fair, circa 1940,
Treasure Island, California.
Family collection.

In English, writing an address on an envelope entails writing the addressee on the first line, then the house number, street, town, and state. The stamp is placed on the upper right-hand corner. The Japanese do the opposite. First they write the prefecture, then the county, town, house number, and finally the addressee on the last line. The stamp is placed on the upper left-hand corner.

In America we walk right into a house, but in Japan people take their shoes off at the entrance. Instead of chairs, the Japanese sit on a *tatami,* a straw-matted floor, with a *zabuton,* a cushion, under their knees. The use of a knife and fork to cut food on a plate is foreign to Japanese, who use two sticks, *hashi,* to pick up and eat their food.

The spacious airiness of the Japanese living room, *zashiki,* contrasts with the display of household treasures and art objects found in an American living room. Both sides of the Pacific Ocean are rich in their cultural heritage, although the way of doing things in everyday life developed differently. Matsusaburo urged his Japanese American students to study their parents' language and culture so that they could contribute to and enrich society in America, their homeland.

It was approaching Christmastime in 1941. On Sunday morning, December seventh, our family was assembled in the living room, with everyone absorbed in some different activity. Matsusaburo stood before his easel, painting.

Tommy was carving a boat from a piece of wood. I was helping my daughter with her watercolors, and the radio was tuned to a musical program, but no one was paying any attention to it. We often took a ride in the car to the top of an Oakland hill on Sunday afternoons, where we could look out at the beautiful, blue Pacific Ocean, the highway between our former home country and our new one. On this particular day the music began to blare out from the radio. Matsusaburo held his brush suspended in the air and stared at the radio, as if he saw the announcer there in the room.

"What is it?" Tommy asked his father.

"The Japanese have bombed Pearl Harbor," he replied. His voice was low and barely audible.

"What does 'bombed' mean?" Tommy asked, but Matsusaburo did not answer. Perhaps he himself did not know.

Ibuki resumed her watercolor painting and Tommy his carving. Only we parents looked at each other worriedly and listened to each bit of new information that was broadcast over the airwaves. I got up, went to the front door, and looked outside, as if to reassure myself that nothing had changed.

The wind was blowing fiercely over the old walnut tree, and the chickens were busily clucking in the yard as usual. The winter day was cold!

"Will there be war?" I asked. Matsusaburo nodded his head in silence. To us it seemed as if peace had passed out of our lives, and a dark cloud was covering the sun.

Ibuki was too young to attend school, but Tommy went to his fifth-grade class the next day. When he came home, he was very upset because some of the boys in his class had said to him, "No Japanese can be trusted."

"What does it mean, Daddy?" asked our ten-year-old son. My husband's heart ached, for he realized that anti-Japanese feelings were already spreading among the young elementary school children.

"There are all kinds of people in the world. Some can be…and some cannot.…" He could not answer well enough for his son to understand. He himself was dismayed that his old country had broken ties with his new one.

In a few days an announcement was issued that all Japanese Americans were forbidden to own shortwave radios, firearms, swords, or cameras. And men in uniform came and posted a bulletin, the "Western Defense Command Instructions to All Japanese," on a telephone pole right in front of our Hayward home on West Jackson Street.

Next, a curfew was enacted. Anyone of Japanese descent had to be home by 8 p.m. We were forbidden to travel beyond a certain distance from our home. In newspapers, magazines, and on radio, the language and words grew more bitter and clamorous, repeating the dangers of having Japanese in the neighborhood. It seemed as though my family's every movement was being watched by hundreds of hostile eyes. It felt as if anything Japanese was

bad! Fear struck me. I began to tear up our Japanese books and to break our phonograph records with a hammer.

Christmas and New Year's Day came and went in a gloomy, uncertain state of anxiety. The song "Remember Pearl Harbor" was flowing from the radio at all hours.

"For reasons of internal security and military necessity, all persons of Japanese ancestry must evacuate the area of the Pacific Coast," stated Executive Order 9066 in early spring of 1942. The area was comprised of California, Washington, Oregon, and the southern half of Arizona. Approximately one hundred and twenty thousand Japanese and Americans of Japanese ancestry were affected. Two-thirds were American citizens born in the United States.

My husband and I were born in Japan and were not allowed citizenship. Matsusaburo had arrived in Seattle as a student in 1906. The Issei could not become naturalized citizens, no matter how many years they had lived in the United States. They had endured various kinds of exclusion laws, and now they faced this government proclamation. In 1942 their American-born children were still young, so the Issei worked until the last minute before evacuation.

Every person who had been called in to be fingerprinted received an identification card with a photograph, a tag with a number to wear, and a typhoid injection.

Tommy and Ibuki still chased the chickens in the yard and made mud pies under the old wal-

nut tree. Matsusaburo and I worked inside the house, preparing for evacuation, although we did not know just what to do with the furniture and all the paintings.

April 30, 1942, was a clear day. A peddler drove up and piled his old truck high with our tables, chairs, the record player, the standing radio, the upright piano, rugs, and many other household goods. He hurled Ibuki's tricycle and Tommy's red wagon into the heap. The man, a stranger, priced the items of furniture himself. He gave me twenty-five dollars for the piano, five dollars for a living-room rug, and so on. Helplessly, the family watched the truck speed away. That same evening the chicken yard was a battlefield for the rooster and five hens. They screeched to resist being caught, yet were soon roped and carried away by a man who lived across the street from us.

"Where are we going? Why do we have to go? Is Mrs. May going too?"

"No," he answered.

"Why?"

Nearby was a Japanese nursery with many rows of greenhouses filled with fragrant red, yellow, and white roses and carnations. Each bud and branch was carefully trimmed and nurtured to produce the very best flowers for the marketplace. There were open fields outside with colorful sweet peas blooming in a tent made of cheesecloth to protect the delicate flowers from insects and the wind. There were strawberry growers with fields of white straw-

berry blossoms. The first spring crop was to be harvested shortly.

The Japanese sharecrop farmers also cultivated thousands of tomato plants. They sowed the seeds in December and January in their houses so that by May the plants that had grown to five or six inches were ready for transplanting into the open fields. And as the danger of frost had passed, many farmers were ready now for this year's transplanting.

May 8, 1942, evacuation day, was a beautiful, spring day. Matsusaburo was up early and watered the vegetable garden, flowers, and trees around the house we rented for ten dollars per month. The hummingbirds were hovering over the honeysuckle vines around the front porch. The dark pink peach tree was in full bloom because it was the time of *Tango-no-sekku,* Boys' Day. The new bamboo shoots were pointing straight up toward the sun. The old oak tree, with its tender, new leaves and sparrows on its branches, seemed to be at peace, saying good-bye to the family.

Ibuki wore a new red hat and carried her doll. Tommy held a bundle and a few books. My husband and I each carried a large bundle in one hand and a suitcase in the other, because instructions read that the evacuees could only bring what they could carry. Mr. Perreira, our landlord, drove us to the Hayward City Park, where the evacuees had been told to assemble.

When our family arrived, many Japanese friends were already there, and others kept

coming. They talked about how they had worked until the last minute to finish what they had started. Many had also watered their flowers and plants for the last time before evacuating. Caucasian women from the Christian churches served hot coffee and sandwiches. None of the Japanese knew where they were going nor why they had to be evacuated nor what their future would hold.

At eleven in the morning we started to fill the Greyhound buses. After a short ride we arrived at a place called "Tanforan Assembly Center." A racetrack for horses, it had been taken over for a new purpose. The horse stalls were converted into housing for the Japanese and their American-born children.

Tanforan Assembly Center

Evacuee families had already filled the newly constructed barracks on the inner and outer perimeters of the racetrack. Our family was led to Barrack 24, "Apartment 6," a whitewashed horse stall. A swinging half-door divided the two rooms, where the front half had originally been a storage place for fodder, and the rear half the stall for horses. The only furnishings in the room were four army cots. There were two windows and two electric bulbs hanging on cords from the ceiling. In the afternoon a big truck brought tons of hay to a vacant lot near the stalls. I was wondering where the horses might be, but what a surprise! We were told to stuff the hay into cloth bags of ticking to make mattresses for our cots.

The partitions between the stalls did not reach up to the ceiling but ended about two feet above my head. Everyone could hear the conversations in the adjacent stalls and tried to be considerate and not disturb their neighbors. We had to walk about half a mile for meals under the grandstand and a block away for the toilet. The children learned the new words "mess hall" and "latrine" the next day.

Our family was very tired after all the excitement and physical exertion of the day, so soon after supper that first night we hit the real hay! A neighbor's electric lightbulb shone over the stall partition, as if it were a streetlight outside the house.

Ibuki, a sensitive girl, could not go to sleep in the strange house.

"Mama," she whispered, sitting up in her cot, "I want to go home. I don't like it here!"

"We will go home," I said softly.

"When?" she asked.

"Yes, when?" exclaimed Tommy, as he too sat up.

"Sometime…the time will come."

"Are you sure?"

"Yes, I am sure," I replied.

The two settled back in their cots to sleep while I lay in mine, thinking. I could hear sounds from the stalls all around me, as others too could not sleep. With the light reflecting from the next stall I looked at my children, now

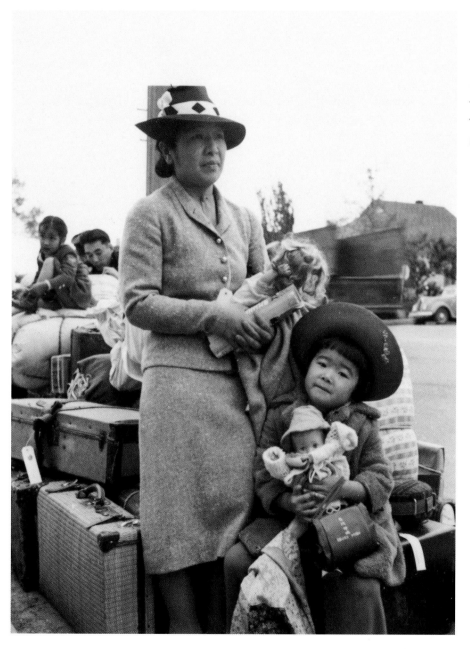

Hisako and Ibuki Hibi, Hayward, California, May 8, 1942, evacuation day to Tanforan Assembly Center. Photograph by Dorothea Lange.

peacefully sleeping. When would we be allowed to go back home? What would be the future for all children of Japanese ancestry? Thought after thought crossed my mind. From somewhere in the darkness from time to time came the sound of voices, and occasionally, a baby's cry pierced the stable walls.

The next morning our family felt a little better. The day was filled with sunshine, and there were many things that had to be done. Some people started to make furniture. They had found discarded wood piled near the barbed wire fences. After breakfast Matsusaburo looked and found some wood to make a stool and a table. Tommy helped him make small shelves. Ibuki and I gathered more wood. Everyone was trying to make his or her stall a little more comfortable.

As we walked around the campsite, we kept meeting old friends from the Bay Area, many of whom we had not seen for a long time. We met friends, and then friends of friends, while waiting at the shower room, the latrine, and mess hall. We waited in long lines for every activity.

In the course of a week or two, the Tanforan population swelled to eight thousand. Among them were college students, some of whom had to be evacuated just a few days before their graduation. There were lawyers, doctors, dentists, professors, farmers, businessmen, journalists, artists, musicians, babies, and handicapped persons and elderly people who had difficulty walking.

There were shortages in commodities, but life went on. Tommy and Ibuki carried their own cups and plates to and from the mess hall. Government instructions ordered that every person was to bring along an enamel cup and plate from home.

Fortunately, the weather was usually pleasant, but it was very windy. I made a *kazeyoke,* a windbreaker, to keep the wind from coming through the front door and up from the floor space between the boards. However, the breeze would blow in just the same, so that my skirt flew up from the air coming up through the floor of the room.

But when it rained the assembly center became really unpleasant. The unpaved roads were mired in mud and so slippery that parents had to hold tightly to their children's hands as they walked to and from the mess hall and latrine.

The evacuees were not allowed to leave the center. Barbed wire fences surrounded the entire compound with watchtowers and military police at the gate. Twice a day, each morning and evening, there was a roll call, barrack by barrack. Miné Okubo, a woman artist friend, was so annoyed that she nailed a sign to her door which read "QUARANTINE."

Gradually, our family tried to adjust to this new life, but we could not forget our own humble Hayward home from which we had been forcefully removed, or our Caucasian friends. Soon we were receiving letters, gifts of fresh fruits, canned goods, seeds, candies, and

toys for the children. Ibuki received a letter from Mrs. May, who wrote how much she missed her "merry" friend.

On visiting day many Caucasian friends came to the center to comfort the evacuees. There were also some friends who kept away from the camp and were never heard from again. One day Mrs. May and her friend brought a box of apricots, a watermelon, and some toys. Miss Dunlop and Miss Gamble, teachers at John Muir Grammar School, came to see Tommy and other former pupils and tried to cheer them up.

On May 18 Matsusaburo received a letter from Mr. Reid, the district superintendent of the Hayward elementary schools. It read, "Best wishes and be sure to call on us if we can assist you in any way." He also received a card from the Oakland Gallery, announcing its seventh sculpture exhibition.

Around one month after we arrived, a new latrine and shower barrack was built across from our stable housing unit. This made life easier for us, especially in bad weather. On May 25 it rained heavily, and the pathways were muddy. Moreover, a small airplane crashed nearby that evening at around 9 p.m., leaving the assembly center blackened all night.

Professor Chiura Obata from the University of California at Berkeley, Miné Okubo, Matsusaburo, and many other associates in the arts convened and established the Tanforan Art School a few weeks after being confined. The adult students created *sumie,* watercolor, and oil paintings. The art supplies were gifts from Caucasian friends or mail-order purchases.

A music school was opened with professional teachers. Soon, beautiful melodies of the piano and violin flowed from the horse stables. Later, a hobby exhibit opened. On display were rings and ornaments made from peach pits rubbed patiently on a cement floor. Residents crafted birds, animals, and dolls from small pieces of wood, using only a few tools. The grammar school opened in early June, as well as a first aid class, which I joined to prepare myself for an emergency. My husband remained optimistic about the future.

It was difficult to be shut out from the outside world, but we were without radios or newspapers except for a mimeographed newsletter that was published at the center. Everyone had a story to relate about the evacuation. The father of a baby boy who was born in a stable had been taken away by the FBI soon after the Pearl Harbor bombing. The young, pregnant wife had closed up a prosperous business and evacuated with her three-year-old daughter, carrying a suitcase, which was all she could hold. There was a widow who had owned a gift shop. She said that she had left all the merchandise there because she did not know what to do at the time, as the order to evacuate was so sudden and unexpected.

Our family received a scrip book worth twelve dollars. Each adult was given four dollars

and each child under sixteen years of age two dollars. Residents were told to use the coupons instead of cash. A co-op store opened to sell necessities, such as toothbrushes and toothpaste, underwear and stockings. Our friend, Mrs. Mayeda, occasionally came over with a clipper and skillfully gave a haircut to Tommy and to Matsusaburo.

On the Fourth of July, 1942, the residents climbed up onto the grandstand and watched a baseball game between the young boys and adults. Little children played under the grandstand seats.

One bright day I went out with my sketchbook and sat near the barbed wire fence and started to sketch the hills of South San Francisco. When we had come to Tanforan in May, the hills were all green. The colors were now already changing from green to yellow ochre. I was busily moving the color pencils and crayons on the paper when an internal security officer came and took away the sketch without saying a word. I was terrified and too afraid at the time to ask him what was wrong with sketching that scene.

In a small space beside the stall's entrance I sowed a few seeds of morning glory, which I had received from an outside friend. In late August one light pink morning glory bloomed. Ibuki was excited. Thereafter, every morning the first thing she did was go out and count the flowers. Some mornings there were five, other times maybe seven or eight. The flowers opened before sunrise in the morning and closed in the late afternoon. The blue, pink, and lavender colors and the trumpet-like forms of the delicate flowers brought smiles and delight to people who passed by the stall.

Traditionally, Japanese people love to improve and beautify their immediate surroundings, no matter where they are. By the end of the month almost all stall fronts were brightened with colorful, blooming flowers. Soon bees, butterflies, and other insects flew about, busily humming and pollinating the flowers. The sun continued to shine upon everything, everywhere, indiscriminately—small or large, good or bad, flowers white, pink, or yellow.

Along the roadside in an empty lot between the barracks, a field of yellow and gold marigolds, dahlias, gladiolus, zinnias, and other beautiful flowers started to bloom. The Japanese cherished the flowers and used them in flower arrangement and painting classes.

And later another hobby exhibit opened. This time there were many more articles on display, such as a walking cane, butterflies, a small boat inside a whiskey bottle, and many other interesting items.

One day in early August Tommy did not feel well, and that evening his temperature rose to 102 degrees. One of our neighbors had two connected stalls because they were a large family. Matsusaburo went over to ask them to kindly be a little quiet because Tommy was sick. Their mother rebutted, "You grind your teeth so

terribly that I can't sleep at night. I never knew anyone who grinds teeth like you do!" The next morning Tommy was taken to an improvised hospital at the center. We learned that he had bronchial pneumonia. After a few days he came back home but could not attend school until he recovered completely.

On August 31 Matsusaburo received a government check of sixteen dollars for his wages as an art instructor. (Later, in Topaz, this amount would be increased to nineteen dollars a month.) The next day at 8 a.m., I went to cash the check, thinking that I would be the first one in line. Instead there was already a long line of about one hundred people waiting. At 11:30 a.m., closing time, the line had not moved much. I went to talk to the guard. He told me that only twenty-eight persons had had a chance to cash their checks that morning and that there would no longer be banking services at Tanforan Center, because the residents would have to start preparing for their move to an inland camp. My husband's life insurance premium had to be paid on September 1, and I did not know what to do with the check.

Matsusaburo brought thirty-five ice cream cakes to Tommy's class for his *Zenkai-yuwai,* a party of gratitude for his recovery. The next day all the parents went to school to attend a ceremony for the closing of classes.

On September 5 at 8 a.m., the residents were told to stay in their stalls, for there would be an inspection of the evacuees' baggage by the military and internal police. Finally, at 3 p.m., two military police officers arrived and opened the suitcases and asked my husband if he had concealed any phonographs, radios, cameras, knives, scissors, or other contraband in our baggage.

On September 19 at 5 p.m., a contingent of about five hundred gathered at Laundry #3, where we were separated into many groups. Car captain, Mr. Aoki, led our Group #8 to the train that started rolling off at 6:30 p.m.

After four months and twelve days at the Tanforan horse stable, our family was being sent to an inland camp, in Utah.

Topaz, Utah Relocation Center

As the train passed through the Bay Area, the evacuees wished to see their former hometowns, fruit orchards, tomato fields, roads, and sky from the train windows but were denied these requests. "All the window shades must be down." This was a strict order and had to be obeyed. Large, black shades were drawn down on every window. Everybody felt sad!

It was a stuffy, sleepless night in the crowded, old coach train for everyone, and elderly persons and small children especially suffered.

At dawn on September 21, 1942, the window shades went up as the train passed by beautiful mountains and then through a flat desert land to the Great Salt Lake and finally to Delta Station at 8 a.m. From there everyone

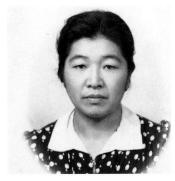

Hisako Hibi, evacuation i.d. photo, January 1942, Hayward, California. Family collection.

Matsusaburo Hibi, Evacuation i.d. photo, January 1942, Hayward, California. Family collection.

Hibi family in front of Topaz barrack home, 1945, Topaz, Utah. WRA photo.

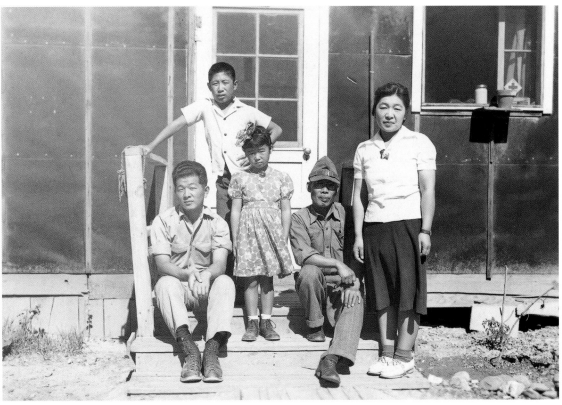

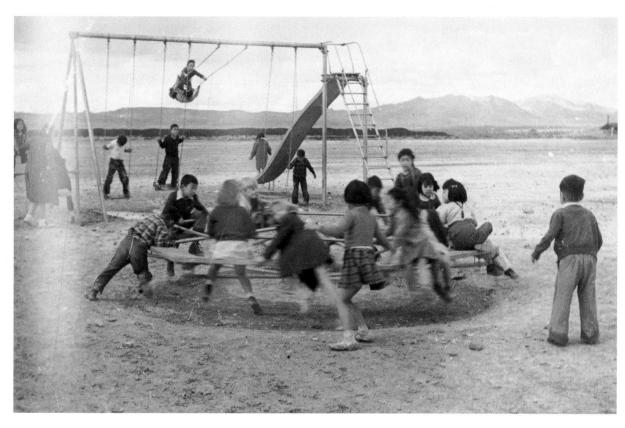

Playground, Desert View Elementary School, circa 1944,
Topaz, Utah. WRA photo.

boarded buses, reaching our final destination at 10 a.m. A Boy Scout band played cheerfully to greet the new arrivals, who were mentally and physically exhausted. The boys had volunteered and had left Tanforan earlier to make things a bit easier for the evacuees. Our family was led to Block 16, Barrack 7, Apartment F, a small corner room with four army cots without mattresses.

The new city was called Topaz Relocation Center. It was one square mile, situated on the outskirts of the Sevier Desert, surrounded by barbed wire fences and watchtowers. Soldiers stood by with bayonets, and MPs guarded every gate. All one could see was an infinite sky, the mountain ranges miles away, and the southern horizon across the vast, broad field of sagebrushes.

Many barracks were still under construction, and many families were put into roofless rooms where they shivered at night. There was a shortage of equipment everywhere—the same as in Tanforan. Ibuki, who was uncomfortable in the new surroundings, kept asking again, "When are we going home?" Sandstorms engulfed the center, and the coyotes howled. The evacuees were shut off from the outer world.

Matsusaburo recited Asian philosophy to his family: "Spring comes after winter; peace comes after war. There are always things to do whether it is winter or spring. Place your trust in heaven in doing today's work. It is a happier,

healthier way of life. We'll all go back home when the war ends."

A barrack was divided into six rooms, four large and two small, partitioned by white Sheetrock. A family occupied one room or sometimes more, depending on the number of people. Each block consisted of twelve barracks, a mess hall, and a building for showers, latrines, a laundry, and a recreation room. There were forty-two blocks in Topaz with a total population of about eight thousand. This newly born city of Topaz was the fifth largest in Utah at that time. Block residents ate and washed together, as if we were members of a communal society without privacy.

The administrative personnel were all Caucasian, many Quakers by religion. The evacuees set up a self-governing system with police and fire departments. Physicians, schoolteachers, farmers, and various other people formed groups. Almost everyone, skilled and unskilled, had some kind of job in the community. Every block elected a block manager who took care of the internal affairs of the block.

Soon an adult education program was set up. Music, art, and sewing schools opened. Flower arrangement, lapidary, and many other classes were organized. The residents attended classes between their jobs.

October 10, 1942: At 4 p.m. the first heavy rain and thunderstorm hit the center since our arrival.

October 12: Each family was provided with a large, pot-bellied stove. It was our family's first

experience with building a fire in a coal-burning stove.

October 15: Block 16 residents decided to finish covering the open ceilings and walls of their barracks before the cold winter arrived. All of the men in the block volunteered for the carpentry work and used the Sheetrock for their work.

October 16: The Block 16 mess hall opened, so families no longer had to walk to other blocks for meals.

October 18: There was a ceremony for laying the cornerstone for the Topaz Community Hospital. Mr. Ernst, director of the relocation centers, and the editor of the *Millard County Chronicle* newspaper were among the speakers.

October 19: This was registration day for the one high school and two elementary schools at Topaz. The next day Tommy, a sixth grader, and Ibuki, a kindergartner, began attending Desert View Grammar School.

October 25: An announcement was made that "due to a shortage of coal and unsettled conditions, grammar school and high school classes are cancelled until further notice."

October 26: The first snow fell. Topaz residents came mostly from the mild Bay Area and felt especially cold. Matsusaburo developed *tsuchikabure,* a condition in which both of his feet became so terribly itchy that he could not sleep at night.

Four standard bathtubs soon arrived for the Block 16 shower room. A traditional home in Japan does not have a shower but instead a deep, round, wooden tub to soak one's body up to the neck. Issei mothers were delighted with the new bathtubs because they loved to take a bath every day. So it would be very unusual if no one were using the tubs, even at midday or very late at night. It was nearly impossible to find an empty one, so mothers bathed their children in the washtubs in the laundry room. These laundry tubs were used for almost every-thing, from washing diapers and dishes to bathing and brushing teeth.

On November 26 there was a roll call at Topaz for the first time and, the announcement stated, "hereafter every Monday night."

Topaz was situated 4,600 feet above sea level. It was dry and hot in summer and cold in winter. Just as the heat was intense in summer, storms in winter were severe in the Sevier Desert. Mud puddles froze, and icicles hung from the eaves. Water turned to ice on the watercolor paper while I was painting, and my fingers grew numb while the brush points stiffened. It was fascinat-ing to see these changes in the art materials. The awesome power of nature aroused certain sensi-bilities in the hearts of artists. Shivering, we kept moving our brushes and persisted in painting.

The golden sunset in the western sky was a beautiful sight to behold—magnificent and forever inspirational. It was a joy to observe and render the scene onto canvas.

On a warm evening after a day's work was done, residents liked to sit in the open field and

watch the young boys play baseball. In the flaming sunset the figures of the boys grew from gray to black against the backdrop, but their movements continued. The colors of the sky changed from gold to scarlet to deeper red and purple and finally to darkness as the day ended.

The little children played *kakurenbo,* a Japanese form of "hide and seek," with their heads poking in and out between the barracks. They ran swiftly here and there, hiding and crawling under the barracks. Mothers shouted, running to tell them to be careful of the poisonous scorpions that hid in the shaded sand of the barracks. After a game or two the children ran to the newly constructed playground, which was equipped with a sandbox, swings, and slides. There they played while the lights went on in the barracks, spots of illumination in the vast darkness of the wide, open spaces.

I recalled the starry, summer evenings in the peaceful village in Japan where I was born, sitting with my grandmother on the *goza,* a straw mat, and counting the infinite number of stars above. I saw a bright one, a dim one, and large and small ones, while I listened to the endless tales of the stars in the heavens. Grandfather usually prepared a lump of *hinoki,* an obtuse, ground cypress resin for fumigation to smoke away the buzzing *yabuga,* mosquitoes, while grandmother busily fanned and beat the *uchiwa,* paper fan, at the large, tenacious, attacking insects. Stories of the heavenly stars continued. Stars were transformed into trees, birds, rivers,

and fairy tales. Long before her grandmother's stories ended, this little girl slumbered away on her knee. Here and there, faint *hotaru,* fireflies, flew, and the loud chorus of river frogs added to the hot summer night scene.

At Topaz, in the distance, immense clouds appeared and disappeared, then formed into shapes and moved away, separating from one form to another and into formlessness. Mount Topaz stood solemnly far away, as though heaven and earth were one.

Once in a while, ominously shaped clouds would start to move rapidly towards the north, while the western sky grew dark. Then the dried sagebrushes would begin to roll swiftly eastward like large balls blown by the fierce wind. The residents had learned from bitter experiences what it all meant. They ran into their barracks and sealed all the openings with old cloth and papers. Cyclones of sand, twigs, and sagebrush roots violently swept over the vast desert floor in a dust storm, as if the earth and sky had become one fierce dust ball in madness. After the storm the windowsills were covered with a thick layer of fine, flour-like, powdery dust.

The residents heard little of what was happening in the outside world. There was a camp newsletter but no radio or newspaper. The chief source of news was visitors and censored letters from friends. Mrs. May wrote to Ibuki and said how much she missed her little friend. Tommy also received a letter, saying how she still had his birdcage, hanging in her garden.

Among the gifts friends sent from outside the camp was tea. At Topaz the older generation missed the gracious ceremony of serving tea, which meant much to their memory. It was one of the aesthetic traditions of Japan that Matsusaburo often said he felt the Japanese in America could contribute to this western culture.

People worked busily in the camp to make their dwelling a little more like a home. They set up wooden boxes for shelves, tables, and benches and put up strings behind their pot-bellied stoves to hang their washed laundry on.

The city of Topaz bloomed in the midst of the desolate land which was so different from the green, fertile land and sea of the Bay Area from which the residents had come. Although they were confined in this internment camp, the detainees worked tirelessly to cultivate sunflowers and later to transplant trees from far-away mountains to make their army barracks a more livable place.

I sowed various flower seeds in a space near my front entrance, but only the native sunflowers grew well without much water. The powerful sunflowers towered above the eaves of the barracks with their seed heads growing to more than a foot in diameter. A strong stem supported them. They bloomed firmly in the white heat of the summer, as though a symbol of existence in their desert life, like the Issei immigrants who had endured the heat and cold and the stormy, political weather. Ibuki had to lean her head far back to see the flowers, as did Matsusaburo, who was the tallest in the family. Soon butterflies and honeybees came to visit. I was delighted to see the paper-thin, delicate, and colorful cosmos blooming alongside the giant, golden sunflowers with their large, dark green leaves. The flowers changed the dusty, dry, barren landscape into a softer one.

During our second year in Topaz, Ibuki had her tonsils removed at the community hospital. By then she spent her time going to school, playing games with her friends, and fetching water in a pail from the laundry room to help her father water the sunflowers. One of the tasks she enjoyed so much was to bring her portion of food from the mess hall to the family quarters so that she could sit down and have dinner privately in a home-like atmosphere.

The residents participated in various activities of the adult education program, and capable, professional instructors taught these classes. They were paid the standard camp salary of sixteen or nineteen dollars per month. The sewing school had a large attendance and offered classes in dressmaking, tailoring, pattern making, buttonholing, and children's clothing, so that students acquired a thorough knowledge of how to create clothing of any style in the fashion world. Every semester the school had an exciting exhibition.

Flower arrangement classes held exhibitions that were fascinating to view. The participants gathered whatever materials were available from

the desert and used them in innovative and creative arrangements.

The agricultural department also had beautiful, unique exhibitions. The detainees produced corn, melons, onions, spinach, beans, and many other vegetables. They cultivated the desert land of sagebrush into a productive, green land and produced fresh vegetables for the mess halls in the camp. At weeding and harvest times all the camp residents were called on to participate in working out in the fields. It was a delightful and rewarding experience for me.

The Topaz Art School was a continuation of the Tanforan school. It had an enrollment of eight hundred students, from preschool-aged children to adults over eighty years of age. There were classes in sumie (brush painting), watercolor, oil painting, design, clay modeling, sculpture, leather craft, mechanical drawing, and lapidary. Matsusaburo and I taught art classes. Ibuki often posed for Matsusaburo's quick sketching classes.

One day a heartbreaking incident occurred at the center. A soldier in a guard tower shot an elderly man to death. I was told that Mr. Wakasa had stepped just a few feet outside of the barbed wire fence. Where could an old man go in the desert with only sagebrush? There was no place to hide, nothing to block the view of Mount Topaz in the west. At nights the coyotes howled. Matsusaburo painted the man's portrait, in his memory. In sorrow everyone attended his funeral in the central field.

While their parents were still confined in camp, many young men volunteered to serve in the United States Armed Forces. They fought gallantly in both the European and the Pacific areas. It was paradoxical that one of the targets of attack for years in the anti-Japanese movement in California was the Japanese language schools, but those who had studied the language performed an important service as interpreters in the Pacific theater of the war.

At Topaz women wore cotton slacks or jeans and a bandana. Men wore Army surplus khaki pants and caps. In the winter they wore heavy, oversized pea coats. We did not have individuality.

Later, permission was granted allowing one person from each block to go shopping once a week in Delta, the nearest town to Topaz. Holding their permit slips and identification cards, the shoppers were packed into an Army truck covered with a dusty khaki rooftop. It was an exciting trip—the sense of freedom away from barbed wire fences.

Soon after came another announcement. Residents were permitted to go hiking and hunting for Indian arrowheads outside the barbed wire fences, yet within a certain area. Scholars at the camp said that a vast ocean had once covered the desert land where Topaz was situated. Therefore, fossils of insects, fish, and other fauna were embedded between the rocks, as well as precious stones, including topaz.

As soon as the weather grew warmer, men and women covered their faces with cloth masks

and tied strings over their slacks at the ankles, as protection from mosquitoes and other insects, and set off on treasure hunts. Tommy often accompanied his father on these expeditions, and sometimes Ibuki and I joined them. When the collected pieces were brought back, everyone examined them. The stones with embedded fossils were carefully slit open so that the delicately formed lines of the ancient creatures would not be damaged. Sometimes, Tommy found a perfect Indian arrowhead.

The lapidary class was popular, and the participants learned how to handle precious stones. The rough stones were transformed into beautiful pins, ornaments, and small sculptured pieces.

Two or three feet into the earth there were tiny shells, no larger than fingernails, which were millions of years old, dating back to the time when the area was covered by ocean water. Here and there above the ground and among the sagebrushes were mounds of white shells as tiny as a pinhead. I carefully sifted the sand and brought the shells home. They were washed and soaked in bleach for a day or two, then dried in the sun to a bright white. In the design class, students learned to assemble and glue these shells. Wire, paper, cloth, and pieces of wood were shaped into branches, stems, and leaves. Watercolor was used for coloring the shells and clear nail polish for adding luster to all the finished pieces. Beautiful shell pins and corsages of gardenias, lilies of the val-ley, little roses, camellias, and pansies were created with these tiny shells buried under the Utah desert.

Also brought back from these day trips were some grotesque-looking sagebrush branches and roots. The branches were then utilized to create unique flower arrangements. The gnarled stalks and roots were rubbed carefully with cloth to reveal their textures, and the stalks also made fine, unusual-shaped walking canes. Also, volcanic stone pieces from the desert were cut and polished into *suzuri,* ink stones.

One day the infamous loyalty questionnaire was passed out to every adult in the camp. It was so contradictory and unreasonable that the residents were in an uproar over the controversial questions. Afterwards, many young people were sent to Tule Lake, an internment camp in California, while families with small children and the elderly stayed in Topaz.

Residents were free to observe their religions. Christians erected a large cross in the central field. On Easter morning before sunrise, worshippers commemorated the resurrection of Christ beneath the great cross. The eastern sky was still in darkness. Then there appeared a red streak across the sky like a symbol of glory. A flush of orange, yellow, gray, and other colors blended in. A brilliant red ball lightly floated up into the midst of the joyful colors. It was a most glorious, beautiful scene.

Under the full August moon, Buddhists in Topaz observed the *Obon* festival. Legend says

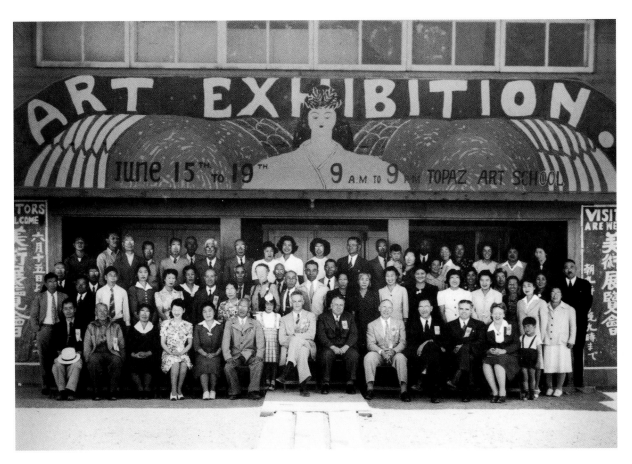

Final Art Exhibition, June 1945, Topaz, Utah. WRA photo.

Hisako and Ibuki Hibi and New York City friends gather to welcome Chiura and Haruko Obata, October 1949, New York, New York. Family collection.

that once a year, on Obon, departed loved ones return to their earthly homes. In Japan on the night before Obon, the entrance of every home is lit up with a hanging paper lantern to welcome the spiritual visitors from the other shore. Filled with joy and gratitude for the past and for the present reunion, men and women, young and old—mothers carrying babies on their backs—joined in the Obon dance in the village square until late at night. The sound of bamboo flutes, *taiko* drums and singing groups echoed through the air to the neighboring villages.

On December 19, 1944, the Topaz Art School held a Christmas party. Outside it was cold, and rain was pouring. There were no fancy presents, yet forty children came anyway and joyfully played and sang Christmas songs in the holiday spirit. When the semester had begun in September, eighty-eight children had registered for the arts and crafts classes. Some of them had already left Topaz with their families.

January 1, 1945: Though New Year's Day was celebrated without *ozoni,* the traditional Japanese New Year's stew, our family was grateful that we were still healthy.

January 2: Schools reopened.

January 3: I received $15.00 from Mr. James Borden, a writer, who had purchased a painting from me when he visited Topaz. Miss Finney, a teacher, wanted my milky weed painting. Since she had been talking about it since last year, I decided to wrap it up and give it to her as a gift.

January 6: *Mochi,* pounded sweet rice, arrived from Kogetsudo in Salt Lake City. Mochi is a part of the New Year's Day tradition, so to be without it would be so sad. Masayuki-san, a railway express worker, delivered the package. The fifteen pounds of mochi cost $6.75, and the delivery charge was 98¢. Block 16 celebrated with a belated New Year's party. There was some chicken, vegetables, cake, and beer. After dinner there were skits and lots of singing. It was a festive, happy gathering.

January 7: The art and sewing schools started up again. Our family continued to accept and to endure camp life.

On August 15, 1945, residents in the camp were surprised to hear of the advent of peace and the end of the war which had started so violently on December 7, 1941. An announcement was delivered that the camp would be closed at the end of September and that everyone should prepare for departure at once. Like scooping up a school of fish with a net, the United States government had uprooted all those of Japanese ancestry from the Pacific Coast area and sent them to inland internment camps. In the course of three and a half years, many young people had already left to serve in the Armed Forces or to enter East Coast colleges, and others to begin a new life in another state where the racial climate was better.

Talent shows, sports events, music, art, and other activities continued to keep the residents occupied. The Topaz Art School had held stu-

dent exhibitions in the fall and spring. The last show was held in June 1945. In the show catalogue Matsusaburo wrote, "Wherever we shall relocate, whatever fate faces us, let us go forward with this saying":

Kono aki wa, ame ka kaze kawa
 shiranedemo,
So no hi no waza ni tagusa torumari.

It is not known whether this autumn will be
 rainy or windy,
But, as for today's task, take weeds from the rice
 field.

This thirty-one-syllable *waka* poem may sound too simple to the ears of young people today, but to Matsusaburo it represented a philosophy of life based on his cultural heritage. It meant to concentrate on taking care of present-day tasks and not to worry about the future. The sun rises, and the moon sets. The earth revolves in relation to the other bodies in the universe, regardless of the consequences of human-made problems. Everything else is transitory. Time changes the scenery of the world.

Every day, Ibuki and I walked to the gatehouse to say *sayonara* to departing friends. The sounds of hammering and people's movements in the camp became less frequent. The mess hall and the shower rooms got quieter, and very soon, one after another, doors began to close for good.

The news from the outside world was sad and disheartening. The torched burning of houses and throwing of rocks were actions taken to obstruct the return of those of Japanese ancestry to their former homes along the Pacific Coast.

On September 23, 1945, our family stepped out of the gatehouse to relocate to New York City. Our children were growing up. My husband and I had felt that the three and a half years in isolation had weighed us down with added thoughts. Matsusaburo was gray with fatigue.

Relocation to New York City

The train from Delta, Utah, to Chicago had been dirty, smelly, slow moving, and uncomfortable. However, the coach train from Chicago to New York City was so bright, modern, and clean that we seemed to be in a different country. We arrived at Pennsylvania Station in New York City on September 25, 1945.

A friend who had left Topaz earlier had rented a four-room cold-water flat on the corner of West 37th Street and 10th Avenue in the Hell's Kitchen district for our family. However, according to Matsusaburo's traditional precepts, the first step in any situation was so important that he decided to have our family's first night in the new city spent at a good hotel rather than going directly to the twenty-dollars-a-month unfurnished flat. He went to inquire about a room at the New Yorker Hotel on upscale West 34th and 8th Avenue. The clerk

politely told him, "There is no vacancy because of a convention in the city." But what did the hotel clerk really think of Matsusaburo when he saw him, with his tired and gloomy face in need of a shave, wearing a crumpled and creased pair of pants and an old coat? He had been on trains for the three days and two nights since we had left the detention camp.

It was autumn, and the air was crisp and the day bright. Without knowing our whereabouts in Manhattan, we found our family's new home happened to be located a few blocks from Times Square. We were amazed to see so many people jostling and pushing one another hurriedly along the sidewalks. No one paid any attention to the newcomers—just four people out of the millions from all nations, creeds, and colors. A grayish blue sky appeared between the crowded, tall buildings. White, blue, yellow, and pink laundry dangled and danced in the windy air on clotheslines strung from windowsill to windowsill.

The next day I took the children to school for registration. As we walked along unfamiliar streets, I felt more nervous than the children. It felt strange to be out once more in the world where there were more Caucasians than Japanese and to see the congested traffic on the streets.

Tommy had been to school in Hayward and was accustomed to being in class with children of other nationalities, but Ibuki had attended school only at Topaz and had never experienced what it was like to be in such a class. Tommy soon adjusted to his high school, but Ibuki's merry laughter had stilled, and she would talk about her friends with whom she used to play in camp.

On the sidewalks along 9th Avenue were table displays of fresh vegetables, fruits, grains, nuts, and other merchandise. At the Italian fish market there were piles of hundreds of fresh fish. Among them were small and large striped bass, so fondly eaten raw by the Japanese as *sashimi,* raw fish, but which could not be bought in California, where they were not considered commercial fish.

Towards 10th and 11th Avenues near the Hudson River, there were sounds of mooing cattle somewhere near the slaughterhouses or from the transporting ferryboat. There was a big store in the heart of Times Square roasting Planter's peanuts. Matsusaburo often bought a two-pound bag, and we wandered along the crowded streets, cracking and chewing the peanuts with enjoyment.

Our family roamed the big city, not knowing exactly where we were. We enjoyed visits to galleries and museums also. One day as I was walking by a nearby children's playground, a six- or seven-year-old boy suddenly came up to me and asked, "Are the Japs coming?" I was surprised and asked him, "Why?" He said, "I am scared because my friends said so." I simply replied, "The Japanese are not coming. The war has ended." He nodded as if he

understood and walked away. I wondered to myself just how these young children visualized the Japanese.

One bright day in November, Ibuki came home skipping and smiling. "Going to school is fun," she exclaimed as she came through the kitchen door. "My teacher is Jewish. There is Mary, a Greek, Fred, a Chinese, Ruby, a Negro, Carmen, a Puerto Rican, Johnny, an Italian, and I am the only Japanese in the class. My teacher said that we are all citizens of the United States of America." She continued, "We made a play today, and my teacher made me the queen and Fred the king. It was such fun." Then she started to sing a song. It did not sound like a song, but I liked it just the same.

It depends on how we look at things.
The brown cow, the black cow, the white cow
Give the same milk.

Ibuki could hardly eat her dinner, because she had so much to talk about. I felt a deep sense of joy at her happiness. Here, perhaps, I thought, was my husband's dream of racial harmony in the United States. True democracy seemed to have bloomed in practice. Tommy and Ibuki studied and played with children of various ethnicities at school.

Our family paid a visit to the Statue of Liberty. The Atlantic Ocean, as blue as the Pacific, was spreading in all directions in endlessness. Matsusaburo's eyes lit up as he repeated his view of the world. "The rivers flow into the ocean. The ocean swallows and takes in everything." And he spoke of the grandeur of nature, water, sun, air, wind, and earth.

The tall bronze lady, holding a torch high in the air, was truly impressive. An inscription at the base noted that it was a gift from the people of France in 1876. A poem by Emma Lazarus was inscribed on a tablet on a pedestal in 1903.

Your huddled masses yearning to breathe free,
The wretched refuse of your teeming shore.
Send these, the homeless, tempest-tossed to me,
I lift my lamp beside the golden door.

The small pot-bellied stove in the kitchen of the apartment did not warm the four-room, cold "railroad" flat. The winter in New York City was cold, just as it was in the Utah camp. Mike, an old Italian man who spoke only in his language, delivered coal for the stove in the winter and later ice for our icebox in the summer.

In January I entered St. Vincent's Hospital for a hysterectomy and was placed in a large ward to recover. In the next bed was a Caucasian woman about fifty years old who made so much commotion before and after surgery that I was astonished. Her behavior awakened me from my conception of Caucasians as a superior race, for Japanese women had learned to endure pain. In California I had been reserved and did not

have such close contact with Caucasians, and of course in the internment camps there was even less contact.

Spring 1946 in New York came in April and was gone with May. In June Matsusaburo started to complain of unpleasant feelings from his right shoulder down to his ribs. X-rays and medical exams could not find the cause of his pain. The doctor concluded that it might be arthritis.

A friend from Topaz was working at the shop of a top-notch Madison Avenue fashion designer, Charles James. She helped me get a job as an apprentice seamstress. Dress orders for evening gowns came from Washington, D.C., and New York high society, and many young, aspiring designers were studying there. There were ten to fifteen girls working under the assistant designer. Our fingers busily moved along the ball gowns like worker bees because these orders had to be finished and delivered on time. Later, this friend moved to the Elizabeth Arden shop on 5th Avenue and worked for Madame Maria, who also made elegant gowns.

In the fall Matsusaburo consulted an Issei physician who at once noticed his jaundice. The Caucasian doctor who had examined him before had not suspected jaundice because he said that he thought Asians naturally have yellowish skin. With still a great deal of hope for the future Matsusaburo died of cancer in June 1947, just one year and nine months after coming to New York City.

I took a walk towards 9th Avenue. There, as usual, people were talking, laughing, and a peddler was shouting. Everybody seemed busy at work, making a living in his or her own way. Up in the sky, white clouds were swiftly moving northward. An uncanny darkness covered the western sky, a sign that a heavy thunderstorm would soon pound the sultry summer day in the city. The storms were just like the ones I experienced in my mountain village in Japan. I recalled the menacing lightning, the ear-breaking thunder, the pouring rain, and driving wind, which formed a spectacular show of heaven and earth in madness. As a little girl, I would run into a nearby shack with my grand-mother to await the weather change. Soon the sun appeared. Cicadas started a chorus, and the storm-beaten soybean plants, sesame, buck-wheat, and sweet potato leaves stood afresh and straight, as if nothing had happened just ten minutes before. Grandmother resumed her weeding, and a baby frog jumped after a fly. Life returned back to normal.

With two young children still in public school, I did not know how to best make a living in the strange, big city. A coworker at the shop had suggested that for a working mother and now breadwinner, it would be much better to join the International Ladies Garment Workers Union (ILGWU), which had a thirty-five-hour workweek and fringe benefits. I was told that the working conditions would be much better at a union shop than at a designer

house, unless one aspired to be a designer. I had no experience in factory work but decided to give it a try.

I was hired for a job at a dress factory near 7th Avenue, in the heart of the garment district, where thousands of experienced dressmakers were already working. I sat on the chair in front of a power sewing machine and timidly put my feet on the pedal. The needle on the machine ran frightfully over the cloth. I was speechless and amazed. There were twenty-five power machines, and the operators sat opposite each other in a row. Everyone was friendly to the inexperienced new employee and taught me the technique of controlling the running machine. One day I was feeding the cloth to the needle-point when the needle caught me on my left index finger. I shrieked. They stopped the power to the machines, and all the operators came over to congratulate me, saying, "Now you have graduated!"

Lorenza, who sat on my right side, confronted me, saying, "Life is tough in America. When I came from Italy, I was just like you— naïve, quiet, polite, but not anymore. I learned that in this country you have to speak out, shout, and if someone hits you, you hit back...pushes you, you push back...otherwise, they will push you around."

Two experienced operators of twenty-five years, Lucy and Benny, sister and brother, who sat on the opposite side also comforted me. Lucy said, "Because of Columbus, I am here now. If Columbus no discovered America, I am not here, and I am in Italy in my nice hometown now. In America you have to work hard just to make a living. Work, work, work, no think, just work."

So we ran, ran all day, feet on the pedals, eyes on the needle, two hands feeding the fabric of the dresses and suits, whatever was in production. How many stitches in a minute? How many stitches in a mile? Truly, the machines ran at full speed. There was no time to think or look for anything. "No think, just run," Lucy said. It was an altogether different world from that which I had been brought up in, and I was often confused, and the needle ran in the wrong directions on many of the clothes.

There was a couple who bought a home on Long Island in anticipation of enjoying the fresh air and country life on the weekends. Once a week the wife brought over a few dozen fresh eggs and sold them to the other operators. They commuted on the Long Island Railroad, but the machine work and the train ride consumed all of their energy, so that they were exhausted on the weekends. The weekend country life became just a dream, so they moved to the borough of Queens to live a simple life.

It was a pleasant Italian shop. The operators sang songs while the machines were in operation. I learned to sing "Mama Mia" and other Italian songs and was able to join the chorus while my machine was running at full speed. I followed my coworkers to the union

Hisako Hibi, Central Park, 1949, New York, New York. Family collection.

Hisako Hibi, George Washington Bridge, 1953, New York, New York. Family collection.

Hisako Hibi at the Museum of Modern Art, 1963, New York, New York. Family collection.

Hisako Hibi at the Lincoln Monument, 1987, Washington, D.C. Family collection.

meetings at Manhattan Center. I gradually began to understand how the dressmakers struggled to gain job security and realized the importance of independence and security, especially for a widow like myself.

Once a week after work I resumed my study of oil painting at the Museum of Modern Art, on 53rd Street. I was happy there. Through painting I could forget everything and go beyond everyday life, as the imaginative world of art is unlimited and infinite.

Return to San Francisco

Time flew! Tommy had already graduated from college, and Ibuki, a junior in high school, wanted to attend college in California. In the summer of 1954, Ibuki and I took the southern train route to Montgomery, Alabama, to see Tommy, who was serving in the Air Force. Just a few hours from New York City, we saw and felt the racial discrimination against the black race in Washington, D.C., and in the South at the train station, on the bus, and in restaurants. The feelings brought back the sad memories of our discrimination and evacuation from the West Coast.

After a twelve-year absence from the Bay Area, many things had changed, but the beautiful scenery of San Francisco had not—the blue water and sky, the good weather, the hills of the city, the Golden Gate bridge, the clanging bells of the cable cars. The renewed, fond memories of the beautiful city by the bay lingered on long after we took off our shoes at the home of a Topaz friend who lived in the Richmond district.

Renting an apartment in San Francisco was a difficult experience. The rental signs were up, but there was always some reason given for why a unit was not available. One afternoon shortly after I returned to the city, I was walking along a street when a group of boys around seven or eight years old began to throw small stones at me from the other side of the street. I went up to them and asked them why they were doing this. One of the boys replied, "Because you are a Jap," and then ran away. Living in New York, I had not encountered such racial reactions for a number of years.

I applied for a sewing machine operator's job at the San Francisco Dressmakers Union and worked at the Lilly Ann and Betty Clyne factories. The atmosphere in these factories was different from New York City. It was much gloomier in San Francisco, but I did not know why. On both coasts the machine operators had to work fast to earn a living. In the spring, around the cherry blossom festival, we were almost finished with the clothes for the fall season, and in the summer we sewed fashion dresses and suits for the following spring. Every season the fashions changed, so we operators had to get accustomed to the styles and textures of the new materials. And we worked the machines at full speed—forwards, backwards, around the collars, over the edges, through

decorative top stitches, and under stitches—seemingly a million stitches a day.

After Ibuki graduated from college I became a housekeeper in a private home and worked for the artist, poet, patron, and cofounder of the Presidio Open Air School, Helen Salz. I was her housekeeper and cook, but I did not know fancy baking nor cooking—only my own home cooking. Her home was a Bay Area model house with skylights, five inner gardens with flowers and shrubs, and open spaces with enclosed wooden fences. It was a beautiful, peaceful dwelling. Domestic work hours were long, yet flexible. I found time to sketch between my cleaning and cooking, and I slowly resumed my painting and artwork again.

In 1960 I became a member of the San Francisco Women Artists group. Later I studied at the University of California Extension program with Ann O'Hanlon and became a member of Sight and Insight/Perception Gallery at Fort Mason, in the city.

Now I felt reborn in the natural beauty of the Bay Area, where I had gone to school and married. I have two children and five grandchildren. Time heals wounds.

Postscript

My profound respect and admiration go to all the Issei mothers who endured unspeakable hardships in the bitter, racially discriminatory society of the time. In silence the mothers patiently helped their husbands, raised their children, and overcame obstacles in an unfamiliar new land. Among the picture brides were many well-educated women, but the social conditions necessitated that they work on farms and as domestics, in situations that they had never experienced in Japan. At remote farmhouses there was neither electricity nor running water; water had to be pumped from underground wells. Grocery shopping was nothing like today's supermarket, where products are conveniently wrapped and packaged. Many used gestures to communicate because of language difficulties. One woman said that she had to cackle like a hen to be directed to some eggs on a store shelf. And Issei mothers often suffered from problems related to sickness and to childbirth.

At the time of the evacuation in May 1942, we left all of our paintings to the Hayward community in the care of Will Frates, a Hayward artist. He had already passed away by the time we returned in 1954. My fate, which seemed to change and move both forwards and backwards, caused me to undergo evacuation to the internment camps and relocation to the East Coast, followed by the death of my husband and my return to San Francisco.

San Francisco Women Artists honor
Ruth Asawa at Louise K. Davies
home, c. 1980, Atherton, California.
Photo by Stefanie Steinberg.

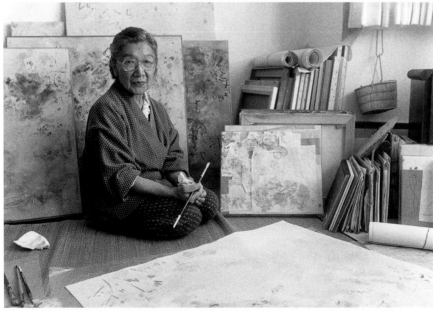

Hisako Hibi portrait,
1985, San Francisco,
California. Photo by
Terry Lorant.

Only my work in art gave me consolation and comforted my spirit. After Matsusaburo's memorial exhibition in 1962 at the Lucien Labaudt Art Gallery in San Francisco, I donated his internment camp paintings, pencil sketches, and wood and linoleum prints and blocks to the Japanese Issei History Project at the University of California at Los Angeles.

In regard to my own paintings, the camp scenes are mostly oil on canvas. I painted them as I saw them. However, I did not paint purposely or consciously, so the paintings speak for themselves. The paintings render the social conditions of the internment camps at that time. For instance, the seasonal harshness on the camp internees in the winter is depicted, as are an old couple walking aimlessly in the desert and children being bathed in the washing tubs.[1]

Along my path I met many thoughtful and kind art mentors. Just before the evacuation in May 1942, I visited the San Francisco Museum of Art (now the San Francisco Museum of Modern Art), thinking that I might never have a chance to return there again. One of my paintings, *Spring,* was hanging there for the San Francisco Art Association annual exhibition. How happy I was to meet my artist teacher, Gottardo Piazzoni, in the gallery. We sat on a bench, and he comforted me by saying, "Keep on. Just keep on. Life may be hard sometimes, but just keep on painting when you can." His words were deeply instilled in my heart and are still with me to this day.

In 1952 I entered Victor D'Amico's art class at the Museum of Modern Art in New York City. He pointed out my inner, seeing eyes and told me, "Color is your vocabulary. Try to paint your own statement." Those were invaluable words, which I am still trying to follow.

In 1965 I attended Ann O'Hanlon's University of California Extension art class. One day at a beautiful spot in Russian Gulch, near Mendocino, she said, "Hisako, try a twig instead of a brush." Up until that time, the brush was the only means I used to paint on paper or on canvas. Since then, I have tried using weeds, pebbles, driftwood, tear-and-press, cut-and-paste, and have enjoyed the adventure of discovery with found objects. Inward and outward, old and new, there is no end to the freedom of expression in art.

I was granted United States citizenship in 1953. Since then I have participated in local and national elections and I have begun to think of the society in which we live and of my heritage more deeply than before. I do not know exactly when or how, but perhaps around 1964 or 1965 the colors in my paintings became brighter and much freer in the expression of objects. My paintings became less representational.

I believe our Asian ancestors nurtured our minds to love and respect the natural ways of life. Spring comes after the cold winter. Water

1. The majority of these oil paintings of Tanforan and Topaz were donated to the Japanese American National Museum in Los Angeles after Hisako Hibi's death.

flows from high to low. Flowers bloom and wither, accordingly, in a rhythmic harmony of interdependence of all things in an indiscriminate way.

Life is transitory.

Yesterday's flower is today's dream.

Everything changes in time and condition.

I thought the terrible war ended on August 15, 1945. Quite the contrary, fiercer fighting and war, and evacuations of people, seem to continue in a human tragedy today in other parts of the world. I see and hear helpless mothers and their crying children.

Through our own bitter experiences of World War II, I hope to contribute something positive towards a better future and a peaceful existence for all people on Earth.

Forever moving, changing the forms of human-made society in the vastness of the universe, I seek something beautiful with line, color, and form in such a way, wishing to convey a message of peace.

Art consoles the spirit, and it continues on in timeless time.

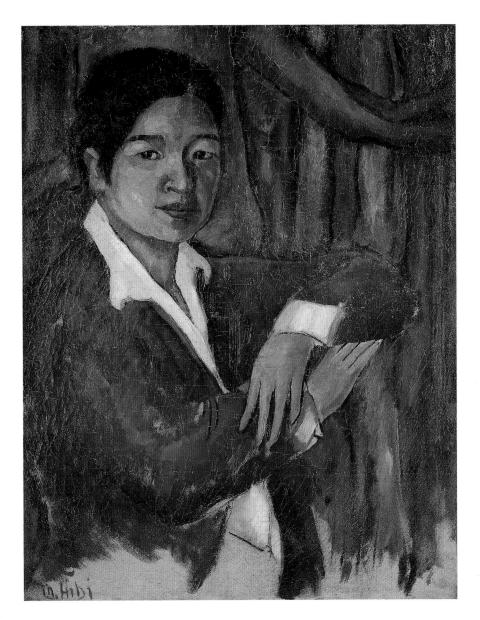

Hisako Shimizu, 1930, 26 x 20 in., oil on canvas, painted by Matsusaburo Hibi, San Francisco, California. Family collection.

This is an oil portrait of a younger Hisako, painted by her male admirer and future husband, Matsusaburo Hibi. They were married in 1930.

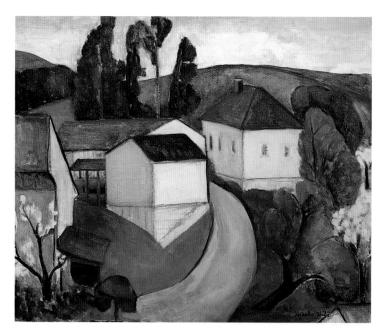

Spring #2, Hayward, 1949, 20 x 24 in., oil on canvas, Hayward, California. Family collection.

Spring was a favorite subject that Hibi returned to throughout her painting career.

Apricot Trees along Jackson Street, circa 1940, 20 x 16 in., oil on canvas, Hayward, California. Family collection.

Hibi wrote on the back of the painting, "Painted at Hayward while we reside on 16 Jackson St. Lots of apricot trees and cherry trees were planted in Hayward to Mt. Eden along Jackson St."

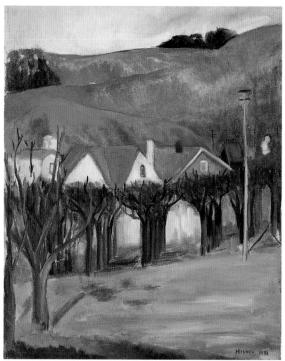

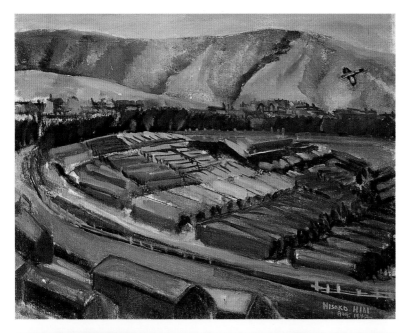

Tanforan Assembly Center, August 1942, 16 x 20 in., oil on canvas, San Bruno, California. Courtesy of the Japanese American National Museum.

Hibi's inscription on the back of the painting reads, "Tanforan Race Track, Tanforan Assembly Center, San Bruno, Ca. We stayed May 8–Sept. 23, 1942." The perspective of the painting offers a panoramic, bird's-eye view of the camp, Hibi's imagined vision of the grounds from a distance. The shallow space of the painting and the use of a high horizon contribute to the cramped feeling of the work. The bird flying in the top right corner is the only sign of movement and life in this otherwise somber canvas.

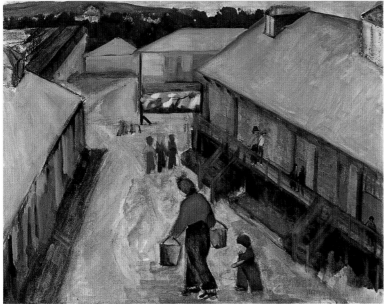

A Few Renovated Horse Stables, August 1942, 16 x 20 in., oil on canvas, San Bruno, California. Courtesy of the Japanese American National Museum.

How could she have known that she and her family would be relegated to live in a horse stable? The internees kept busy, trying to make the best of their new life situation.

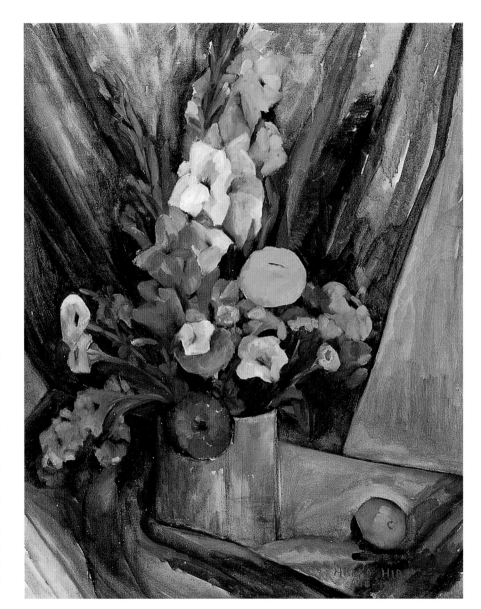

Flowers, August 1942, 25 x 20 in., oil on canvas, San Bruno, California. Courtesy of the Japanese American National Museum.

Hibi wrote, "Their beautiful flowers were cultivated in a vacant lot near the stables by the evacuees since they were interned." For this painting, she received a twenty-dollar award for the best flower painting at the Relocation Center Art Exhibit in Cambridge, Massachusetts, in May of 1943.

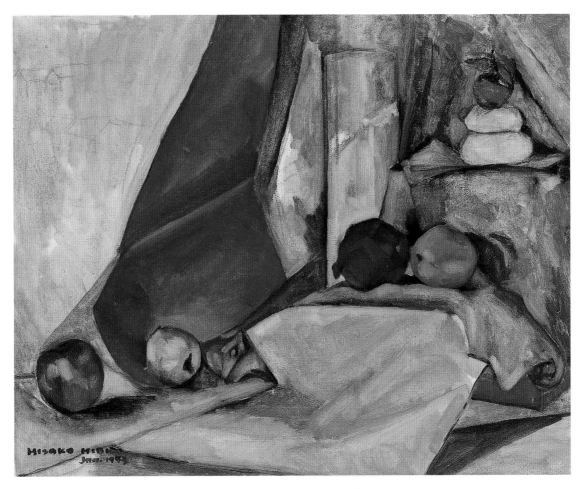

New Year's Mochi, 1943, 16 x 20 in., oil on canvas, Topaz, Utah. Courtesy of the Japanese American National Museum.

Hibi's inscription reads, "Japanese without mochi (pounded sweet rice) is no New Year! It was very sad oshogatsu (New Year). So, I painted okazari mochi in the internment camp."

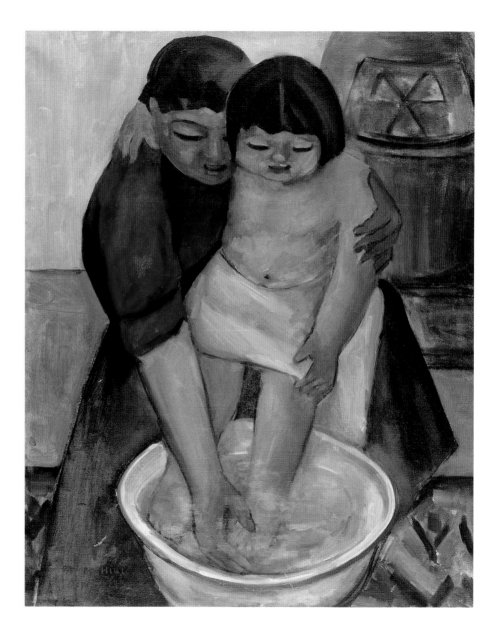

Homage to Mary Cassatt,
1943, 24 x 20 in., oil on
canvas, Topaz, Utah.
Family collection.

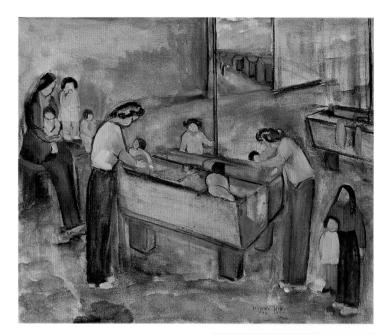

Laundry Room, August 1943, 20 x 24 in., oil on canvas, Topaz, Utah. Courtesy of the Japanese American National Museum.

Hibi wrote on the back of the painting, "We had only four bathtubs. Mothers bathed children in the laundry room." In the background of this painting, an open doorway reveals a row of barracks, making the setting unmistakable.

Mess Hall, circa 1944, 20 x 24 in., oil on canvas, Topaz, Utah. Courtesy of the Oakland Museum of California.

The mess hall was a mass gathering at mealtimes, a place for families to unite or disunite. Young people often chose to eat with their peers. Feelings of uncertainty, conflict, and resignation must have reigned in the crowded dining hall.

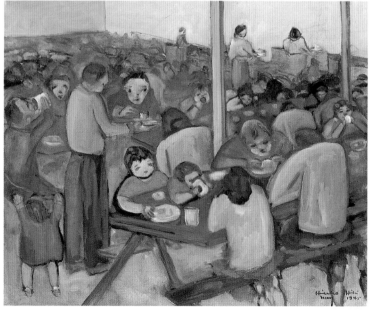

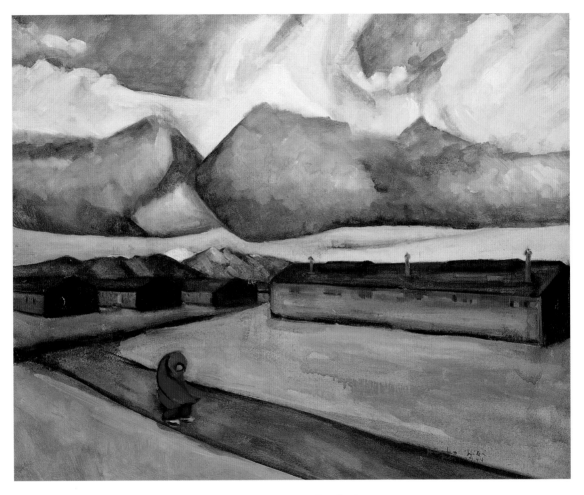

Windy, February 1944, 20 x 24 in., oil on canvas, Topaz, Utah. Family collection.

Hibi said of this painting, "It was a very windy day and I saw my daughter coming home from school and [she] was almost blown off."

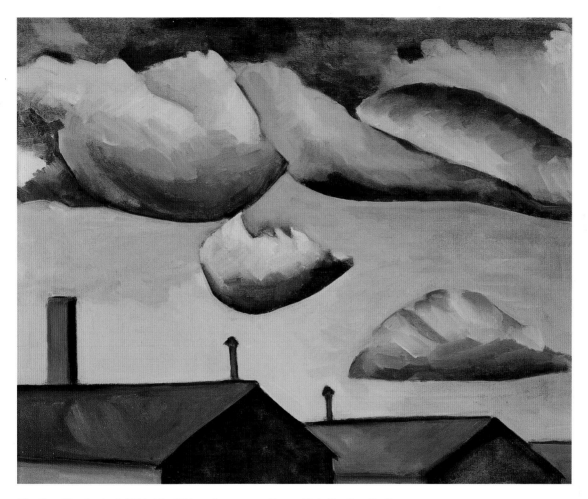

Floating Clouds, April 1944, 18 x 22 in., oil on canvas, Topaz, Utah. Family collection.

Hibi wrote on the back of the painting, "I wanted to be free, as free as the clouds in the spacious sky."

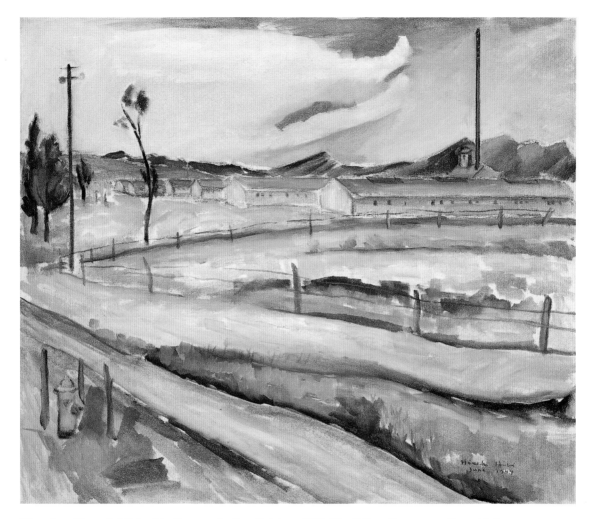

View from Topaz Art School to Community Hospital, June 1944, 22 x 26 in., oil on canvas, Topaz, Utah.
Courtesy of the Michael D. Brown Collection.

This painting from Block 7 looked over to the hospital, which was located outside of the internees' barracks. Hibi wrote, "There were lots of mosquitoes and we could not go to the field to paint. So we painted at Art School ground."

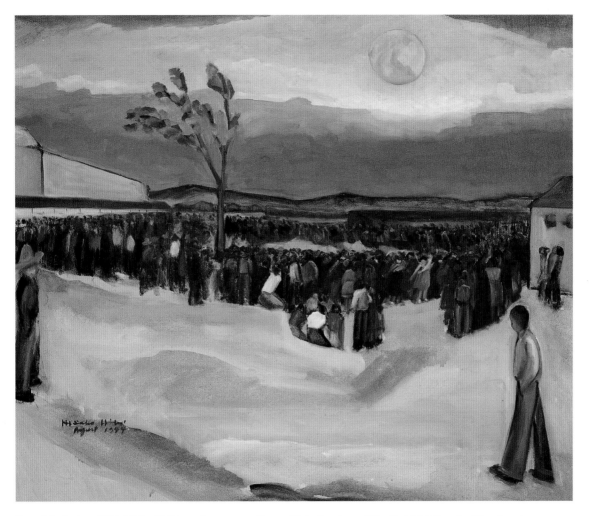

Bon Odori, circa 1944, 21½ x 25 ½ in., oil on canvas, Topaz, Utah. Courtesy of The Buddhist Church of San Francisco.

This Buddhist festival was celebrated during the August full moon. It is a joyous time of homecoming in Japan, where villagers gather and dance merrily under the light of the moon and welcome the brief return of passed loved ones.

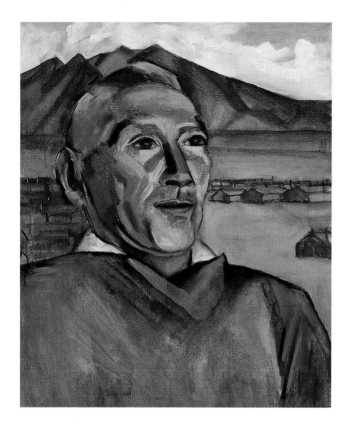

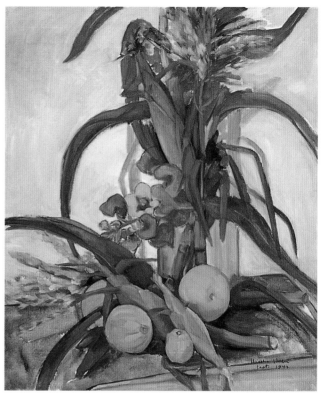

A Study #1, June 1944, 20 x 16 in., oil on canvas, Topaz, Utah. Courtesy of the Japanese American National Museum.

This internee posed for the oil painting class. Camp barracks serve as a backdrop to the portrait. Hibi did not often paint people in such great detail; in her work, people usually appear diminished in size and lacking specificity.

Topaz Farm Products, September 1944, 26 x 22 in., oil on canvas, Topaz, Utah. Courtesy of the Japanese American National Museum.

Hibi wrote on this painting, "Tribute to Topaz Agricultural Dept. They provided us the fresh vegetables. They feed us with the finest, freshest vegetables." Internees created the Topaz agricultural department for a few different reasons. It was one way to pass the time during the otherwise boring days, and professional gardeners, of whom there were quite a few in the Japanese American community, could put their expertise to work for the good of their fellow internees. Hibi repeatedly remarked on her admiration for those who cultivated the alkaline soil of the desert.

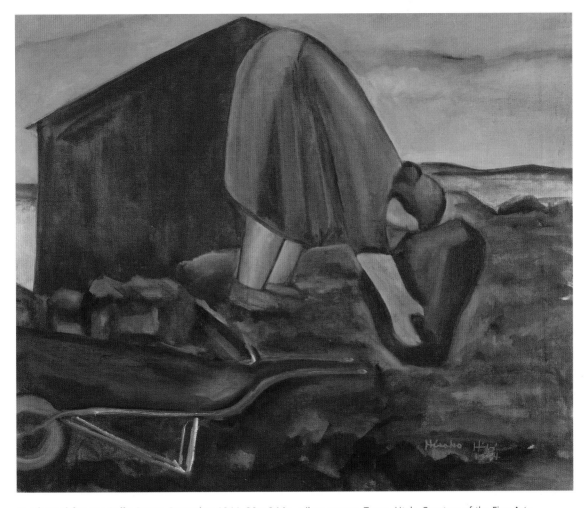

Fetch Coal for Pot Belly Stove, December 1944, 20 x 24 in., oil on canvas, Topaz, Utah. Courtesy of the Fine Arts Museums of San Francisco, gift of Ibuki Hibi Lee.

Internees gathered coal to bring back to their stoves. It was said that some internees hoarded more than their share, and coal could get scarce for those who came later.

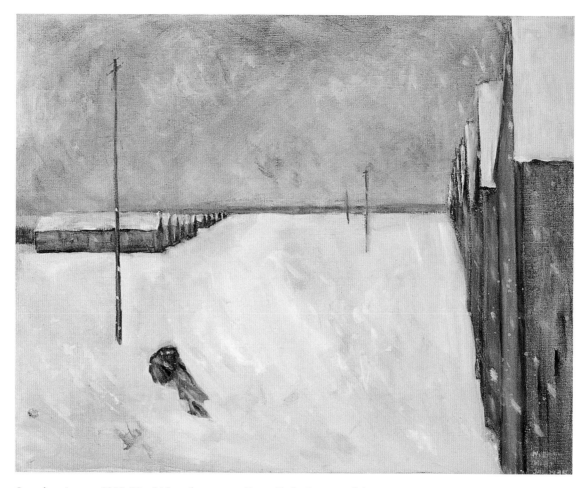

Snowing, January 1945, 20 x 24 in., oil on canvas, Topaz, Utah. Courtesy of the Japanese American National Museum.

Winters were harsh in the Sevier Desert, which surrounded the Topaz camp. Snows and freezing temperatures were common, and long icicles hung from the barrack eaves. The view of camp offered by this painting is a barren one, empty of life except for the lone figure in the foreground. At the right, Hibi portrays a long row of barracks at a severe angle, framing the image and giving a sense of depth to the work: the barracks appear to continue for a long distance, with no end in sight. Daubs of white paint are strewn across the canvas to portray the falling snow.

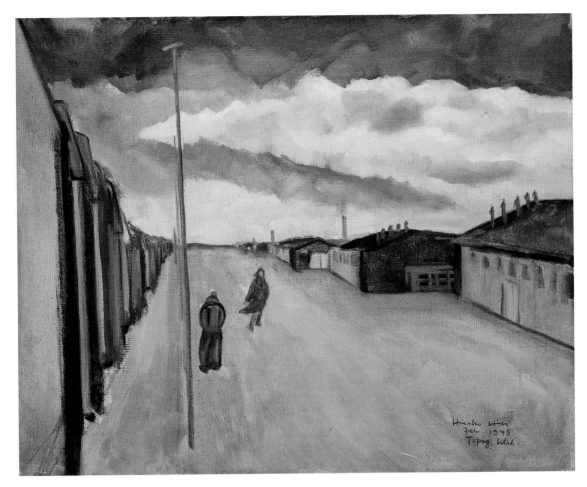

Topaz, Utah, 1945, 16 x 20 in., oil on canvas, Topaz, Utah. Family collection.

*There is only a hint of blue in the sky in an otherwise
barren depiction of Topaz.*

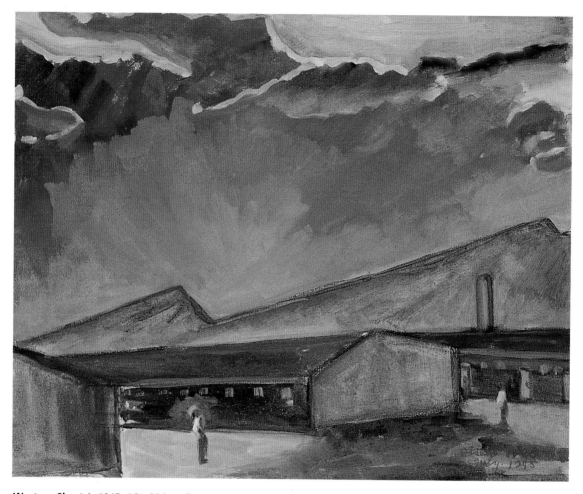

Western Sky, July 1945, 16 x 20 in., oil on canvas, Topaz, Utah. Courtesy of the Japanese American National Museum.

Sunrises and sunsets were awesome to behold—brilliant in the desert setting under a full sky. Hibi wrote in her memoir, "The golden sunset in the western sky was a beautiful sight to behold—magnificent and forever inspirational. It was a joy to observe and render the scene onto canvas."

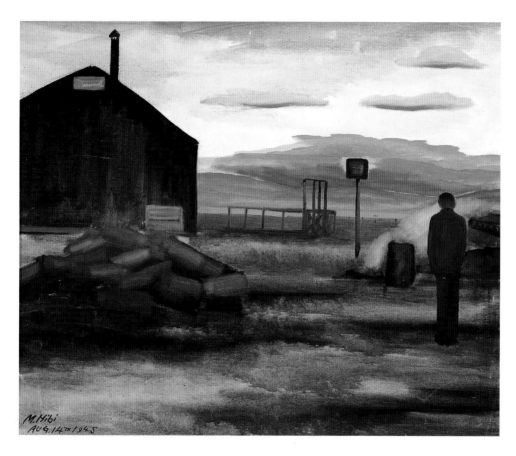

The Day of Japan's Surrender, August 14, 1945, painted by Matsusaburo Hibi, 20 x 24 in., oil on canvas, Topaz, Utah. Courtesy of the Japanese American History Archives and Seizo Oka.

George Matsusaburo Hibi loved the United States and had never returned to Japan since arriving in 1906. Yet he realized the tragedy of the war for his homeland, which had suffered humiliating defeat and casualties. He wrote in Japanese on the back of the painting: "…I contemplated the sunset, my heart heavy with the knowledge that, on this day, August 14, 1945, the Japanese empire had collapsed—an empire which had boasted of a perfect record in her three-thousand-year history. In spite of their exclamations of 'Death, if not victory!', our compatriots in Japan were unable to prevail against the might of the atomic bomb and have unconditionally surrendered in obedience to the Imperial Command. This very day, the setting sun in the clear western sky reflects the sorrowful downfall of the Empire of Japan. There is nothing left for us but to face the skies of our fatherland and weep."

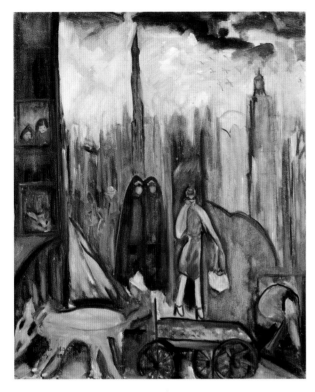

Frightful New York City, 1946, 24 x 20 in., oil on canvas, New York, N.Y. Family collection.

Emerging from three years and five months of life in the internment camps, Hibi viewed the sea of humanity in all its big city grandeur and horror. The inscription reads, "DEVILish, NYC I felt at that time."

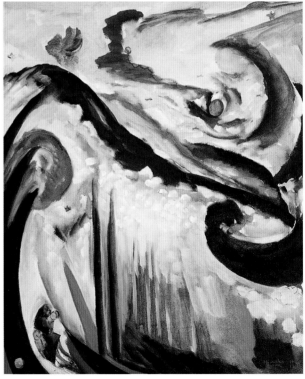

Fear, April 1948, 25½ x 21½ in., oil on canvas, New York, N.Y. Courtesy of the Michael D. Brown Collection.

Ten months after the death of her husband, Hibi painted the inner turmoil she felt when confronted with the personal struggles that lay ahead for a widowed, anonymous mother in an immense metropolis.

U.N. and Its Struggle For Peace As I See It,
1947, 39 x 31 in., oil on canvas, New York, N.Y.
Courtesy of the Michael D. Brown Collection.

*Living in the heart of Manhattan, Hibi greatly
admired the newly created United Nations and
its quest for world peace.*

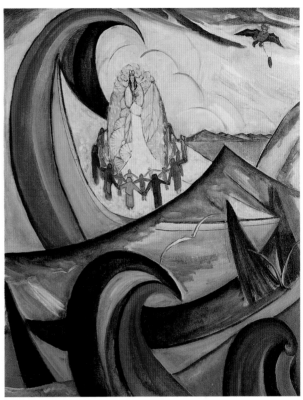

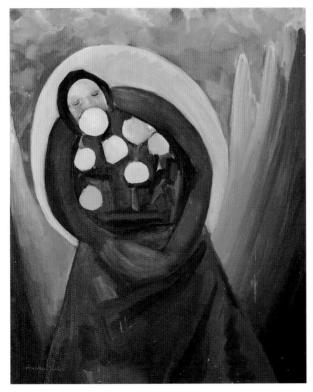

Mother's Day Present, 1948, 24 x 20 in., oil
on canvas, New York, N.Y. Family collection.

*In May 1948, Satoshi and Ibuki presented
their widowed mother with chrysanthemum
flowers on Mother's Day.*

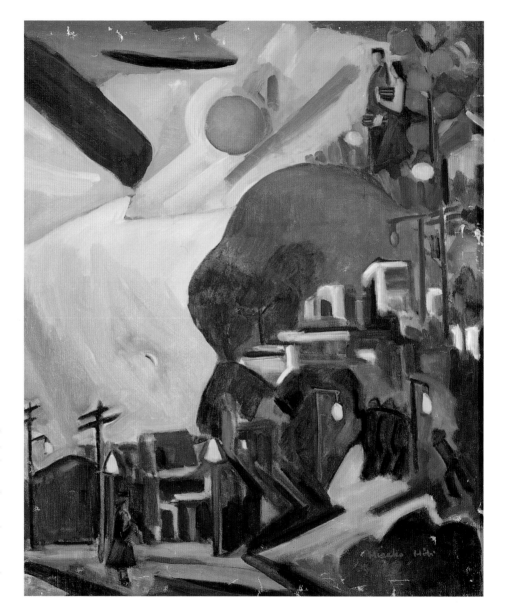

Waiting for a Bus to Work, 1955, 24 x 20 in., oil on canvas, San Francisco, California. Family collection.

Hibi's inscription on the back of the painting reads, "Waiting for a bus at 2nd and Clement Street to transfer at 10th Avenue to Apparel City to work at Lilli Ann dress shop." Hibi told collector Michael Brown that the two figures at the top of the painting represent her children, for whom she so wanted a good education.

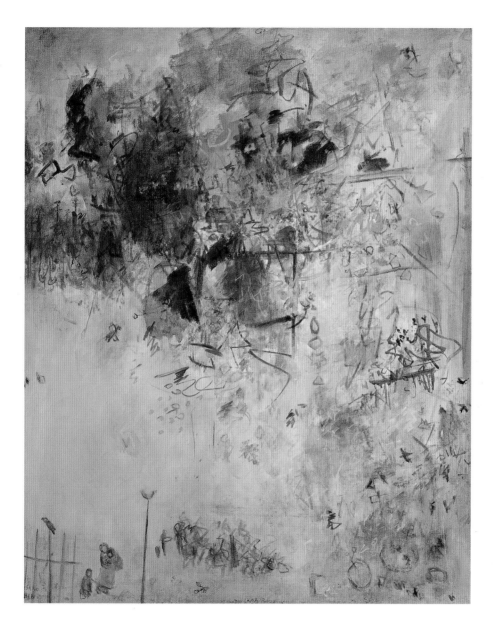

Autumn, 1970, 38¹/₂ x 31¹/₂ in., oil on canvas, San Francisco, California. Family collection.

Hibi understood life and its heartbreaks, and autumn was her favorite season to render onto canvas. She tried often to capture its beautiful colors.

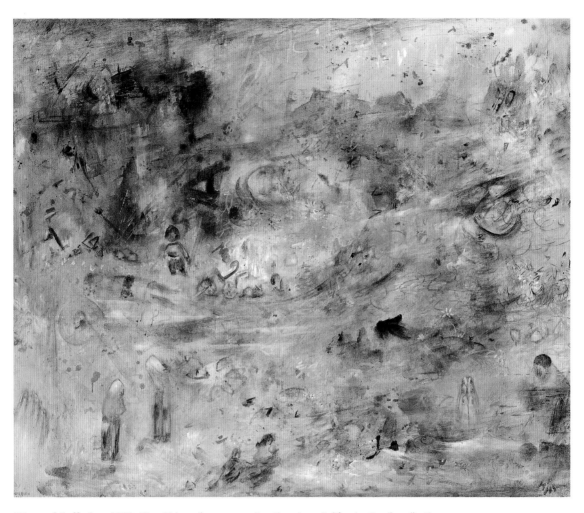

War and Suffering, 1982, 35 x 42 in., oil on canvas, San Francisco, California. Family collection.

Hibi was a painter who wished that she could take viewers to higher ground via fine art. With background colors cloudy and gloomy to represent the devastation of war, she superimposed patches of bright brushstrokes to depict hope and light.

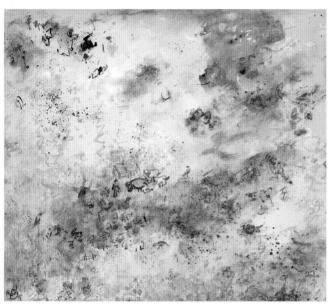

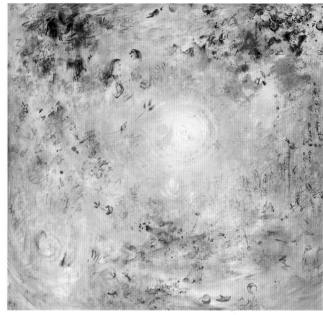

A Spring Garden, 1980, 21 x 24 in., oil on canvas, San Francisco, California. Family collection.

This abstract work displays Hibi's maturity as an oil painter and her ability to put down paint on canvas (as compared to Spring #2, Hayward*). She was able to express the new life and vitality of this season by her use of color and brush.*

Four Seasons, 1983, 40 x 44 in., oil on canvas, San Francisco, California. Family collection.

The seasons of the year and its natural cycles were recurrent themes in Hibi's paintings. Here, she tries to capture their essence in a subtle color presentation.

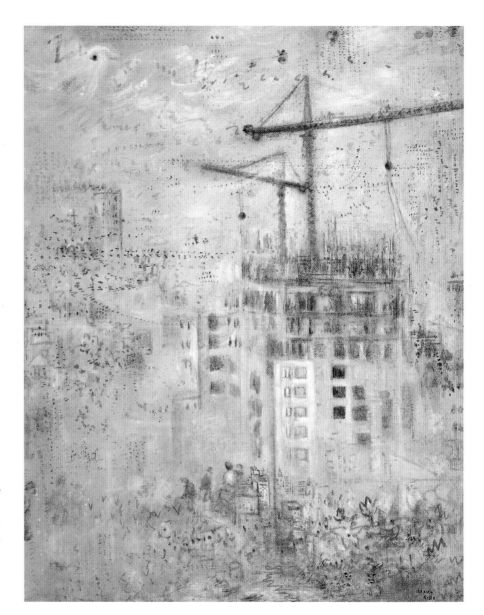

Construction, 1985, 39 x 31 in., oil on canvas, San Francisco, California. Family collection.

From the wide window of her ninth-story residence, Hibi marveled at the cityscape. Here she focuses on the construction crane, a metaphor for building, growth, and creation.

Epilogue

IBUKI HIBI LEE

Over sixty years have passed since Pearl Harbor. Since my mother's passing, we have entered a new millennium, and the United States has undergone economic, political, military, and terrorist crises. Yet the injustice of the Japanese American internment camps has not been forgotten, thanks to the men and women who knew the significance of their history and worked hard to educate all Americans. My mother particularly knew personally the late Edison Uno (1929–1976) of San Francisco, a true leader in the community, among others, who dedicated himself to the cause of justice and redress for Japanese Americans.

The Japanese American National Museum was established in 1992 in Los Angeles to "promote understanding and appreciation of America's ethnic and cultural diversity by sharing the Japanese American experience." The museum has grown and been successful in all aspects of their mission. In 1999 paintings by Hisako Hibi, predominately those executed at the camps, were displayed in their new galleries for six months.

The California Civil Liberties Public Education Program (CCLPEP) was created in 1998 for a five-year period and has funded multiple projects to educate the California public on the unique Japanese American experience stemming from the war years. New books, artworks, exhibits, documentary dramas, and oral histories are a few of the creative enterprises in the program's accomplishments.

My mother's artwork has continued to be exhibited in art shows throughout the past decade, as interest has not waned in her paintings. Her art has also been printed in many books and continues to be. She remarked, "Art is timeless." Art was her refuge and strength. Other words still ring in my ears: "Even with all its problems, we are so lucky to live in a free country like the United States. It is still the best country in the world!"

Afterword: Hisako Hibi in Context

JIM OKUTSU

Hisako Hibi's narrative is subtitled "Memoirs of an Issei Woman Artist," but, in fact, it is even more than that. It provides a history lesson on the Japanese American experience, as her biography refers to so many significant events that took place over the first half of the twentieth century. It is a story that begins with her birth in 1907 during the Meiji era in Japan. It was in this period, which ran from 1868 to 1912, that the Japanese first began immigrating to America. Hisako herself came to the U.S. in 1920, just a few years before the federal government restricted Japanese immigration in 1924. While she mentions many of these significant historical events in her narrative, her culturally influenced writing style presumes that the reader is already knowledgeable about them. So, for those who might want a greater understanding of the Japanese American events that Hisako recounts, I suggest logging onto the Japanese American Network at www.janet.org, where there is a link to its Japanese American history section. On that link is an extensive listing of educational and resource sites.

The World War II period is by far the most significant episode in Japanese American history, with the unprecedented imprisonment of 120,000 Americans of Japanese ancestry by our government. It is this period that is the focus of Hisako Hibi's memoir. The Hibi family spent World War II incarcerated first in a horse stall at Tanforan racetrack, near San Francisco, and later at Topaz, Utah. Yet despite the wartime internment and her own personal and family trials, true to her Japanese roots, Hisako remained an optimist throughout it all. This is because the Japanese are taught not to dwell on the past or on the negative, but to persevere and look to the future. And for Japanese Americans, vindication also came about in due time, for in 1988, President Ronald Reagan issued an apology for their unjust treatment, and the federal government awarded $20,000 to internees in redress compensation.

In addition to the historical context, I find it important, as well, to provide a cultural context to understanding Hisako Hibi, as a woman and an artist. Hisako identified herself as an *Issei,* or first-generation Japanese American; however, she actually was a *yobiyose,* or second-generation Japanese American born and raised in Japan. Much of her memoir centers on her relationship with her husband, Matsusaburo, and her two children, Tommy and Ibuki. This focus on the husband and children is paramount in Japanese culture, as the woman's role first and foremost involves nurturing and spiritually supporting the family.

Although it is clear that art played a secondary role to the family, it was very much a part of her identity, as well as an extremely important means for her self-expression. Hisako had ample opportunity to express herself during the wartime internment. Art flourished in the detention camps as a way for the detainees to pass the time. And, certainly after her children had grown up, she could concentrate her energy on creativity.

I first met Hisako when I produced the first of two Japantown group exhibitions of artwork from the internment camps that included her paintings. I was amazed to learn that she was seventy-two, because she came across as my contemporary—so vital, energetic, and independent. On one occasion, she spoke of her paintings from the wartime internment. Many of her landscapes depicted stark and bleak scenes through her use of blacks and grays and white tones. Hisako commented that she had not realized just how sad she must have felt at the time about the imprisonment and war. Some of these thoughts were expressed in the Japantown camp art catalog. Of Tanforan, Hibi said:

> *Looking over the barbed wire fences, the hills of South San Francisco were already changing color from green to yellow ochre. The children played between the horse stalls, and I felt sad. My painting became cloudy and gray. One day, I was sketching the dark green eucalyptus leaves behind the stalls with South San Francisco in the background. An internal security officer came and confiscated my sketch without a word. At that time, I was scared and too afraid to ask him, "Why could I not sketch that scene?"*

Some of her oil paintings from the Tanforan and Topaz camps reflect what she described as a "mother's feeling." "As helpless as I felt looking at the barbed wire fences, I prayed for peace and painted it."

In her later years, Hisako's gentle strength, determination, and warmth of character—and sense of serenity—were so evident; she was clearly at peace with herself. And it showed in her artworks. Her paintings were very brightly colored, with representations of ephemeral figures floating in space and of Buddha and concepts of harmony.

The last time I saw Hisako, I ran into her at an art museum. She had ventured out, as she often did, to check out an art exhibition—ever so curious, ever the artist.

Acknowledgments

In the early 1950s my mother felt the void in American history left by the silence of the general public in regard to the Japanese American experience in the United States during World War II, and she expressed her wish to me to write her own memories. She had been an oil painter, and her painted canvases from our internment camp period were tightly rolled up and bound away in hidden corners of rooms, not to be exposed for years to come. She was a visual artist, not a writer, yet she began in her imperfect English to slowly transcribe her life and times. She would work at various jobs, raise her family, move from the East to the West Coast, travel, and battle her recurrent cancer. Decades went by, while this wish to write down her thoughts persisted. It was during the last ten years of her life that she finished her latest version.

Shortly before her death in October 1991, she asked a few things of me, including the further editing of this manuscript. Already more than a decade has passed since then, and I have tried to fulfill her request with the assistance of many others who have helped, encouraged, and supported this project.

My mother thanked her teenaged grandchildren, Kenneth, Amy, Peter, and Eric, and her son, Satoshi, for earlier corrections of her English grammar. She also expressed gratitude to Professor Jim Okutsu of the ethnics studies department at San Francisco State University for his computer draft of the manuscript in 1988 and his "much encouragement."

Over the years, many of her friends provided her with emotional and moral support, including Michael D. Brown, Bob Hanamura, Jo Hanson, Kimi Kodani Hill, Eric Saul, and Daisy Satoda. The San Francisco Women Artists group, the Mill Valley Sight and Insight Gallery with Ann O'Hanlon, and the National Japanese American Historical Society in San Francisco all promoted her artwork.

In 1999 the Japanese American National Museum in Los Angeles held a retrospective art exhibit of oil paintings by Hisako Hibi called *A Process of Reflection,* curated by Kristine Kim. I am indebted to Kristine and to the museum, as well as to Director Irene Hirano and Senior Curator Karin Higa for keeping the memory of my mother alive via her artwork.

I would like to extend my deep gratitude to Diane Matsuda, director of the California Civil Liberties Public Education Program (CCLPEP), who has provided me with academic support and encouragement to pursue this book.

Mark Johnson, professor of art and gallery director at San Francisco State University (SFSU), has been my advisor and mentor throughout this past year. I cannot thank Mark Johnson enough for his generosity with time, advice, introductions, and spirit, all of which have helped me to actually realize a book, and for his deep appreciation of my parents' artwork. Mark, with his enthusiasm and energy, always welcomed me into his office space no matter how busy he might be.

Thank you, also, to Professor Jim Okutsu for early help on the manuscript and for his historical overview.

My many thanks go to photographer Wei Chang, who drove from Pebble Beach to SFSU to spend an entire day carefully taking many superb photos that are included in this book.

And my sincere thanks to Seizo Oka and his Japanese American History Archives for his loan of my father's painting *The Day of Japan's Surrender,* and for his translation of the writing on the back of the painting.

And then, thanks once again to JANM curator Kristine Kim for offering her knowledge and time, including travel to the Bay Area, for the sake of this project, and to the museum for their loan of their transparencies for reproduction in this book.

And my thanks and appreciation continue to Heyday Books and its publisher, Malcolm Margolin, and its entire staff, especially to project director Patricia Wakida, editorial director Jeannine Gendar, and art director Rebecca LeGates for their time and expertise.

Also, my gratitude extends to Karen Kienzle, curator of exhibits and collections at the de Saisset Museum at Santa Clara University, and to its director, Rebecca Schapp, for their time and enthusiasm in producing an exhibition of Hisako Hibi paintings to coincide with the publication of this book.

This book would not have been possible without the CCLPEP grant and funding from San Francisco State University, where Associate Vice President for Development Carole Hayashino was extremely helpful. Santa Clara University, Heyday Books, and all the above individuals also provided practical assistance.

My youngest son, Marc, has been of recent great help in his careful proofreading and suggestions.

And lastly, thanks to Mich for believing in me and in this project and for all of his support every step along my way.

EXHIBITIONS

Prior to World War II, Hisako Hibi exhibited in group shows including the California State Fair in Sacramento (1934, 1937, 1939), the Oakland Art Gallery (1937, 1939, 1940), and the San Francisco Art Association Annuals (1940, 1941, 1944). She was also selected to exhibit at the Golden Gate International Exposition on Treasure Island, San Francisco Bay, in 1939 and at the Palace of Fine Arts in San Francisco in 1940.

Gradually, after the war, she began to exhibit once again, following her return to San Francisco in 1954. In 1960 she became a member of the San Francisco Women Artists. In the late 1960s she exhibited at the California State Fairs (1967–1970) and the Crocker Gallery (1969–1970) in Sacramento, and with the San Francisco Women Artists in its many significant group shows.

One-person shows:

1970
May—The Lucien Labaudt Art Gallery, San Francisco, CA

1971
June to July—Humanist House Gallery, San Francisco, CA

1977
March to April—*Retrospective,* Perception Gallery, San Francisco, CA

1980
May—*Tanforan, Topaz, Utah Camp Scenes and Recent Oils,* First Unitarian Church, San Francisco, CA

1985
July to August—*Hisako Hibi, Her Path,* Somar Gallery, San Francisco, CA

1986
June to September—*Floating Clouds,* National Japanese American Historical Society, San Francisco, CA

1999
July to January 2000—*A Process of Reflection,* Japanese American National Museum, Los Angeles, CA

Selected group shows:

1972
February to March—*Months of Waiting,* California Historical Society, San Francisco, CA. This exhibit of World War II internment camp paintings travels in *April* to Stanford University in Palo Alto, CA, in *June* to the Dorothy Chandler Pavilion in Los Angeles, CA, and in *November* to the State Capitol Rotunda in Sacramento, CA.

1973
The above exhibit travels in *February* to the Portland Museum in Portland, OR, and in *April* to The Arcade, Cleveland, OH.

1974
The same exhibit travels in *October* to The Pioneer Museum, Stockton, CA.

1976

September to October—A View from the Inside, Oakland Museum, Oakland, CA

1978

April—4 Japanese American Artists, Sargent Johnson Gallery, San Francisco, CA

1979

April—Expressions from Exile: 1942–1945, Masao W. Satow Building, San Francisco, CA

1980

July—Two-woman show, Dialogue of East and West, Perception Gallery, San Francisco, CA

1982

April—Images in Isolation, Masao W. Satow Building, San Francisco, CA

1983

May to June—Subcultural Art/Artifacts, Japanese and Portuguese Influence in Hayward Area, Sun Gallery, Hayward, CA

1988

*August—*Flower-influenced art exhibit by the S.F. Art Commission, Hall of Flowers, Golden Gate Park, San Francisco, CA

1989

March to April—Art of Peering, Pondering, Oohing-Ahing and Interacting, Euphrat Gallery, De Anza College, Cupertino, CA

Throughout the 1970s and 1980s, Hisako Hibi continued to exhibit at numerous venues in association with the San Francisco Art Festivals and her memberships in the San Francisco

Women Artists, the Sight and Insight Gallery in Mill Valley, and with various Asian American women's artist groups.

1990

February to May—Strength and Diversity: Japanese American Women, 1885–1990, Oakland Museum, Oakland, CA. Exhibit included five H. Hibi Topaz, UT, paintings

June to July—Four-person show, Issei to Shin Issei, Meridian Gallery, San Francisco, CA

1992

October to December—The View from Within, Japanese American National Museum, UCLA Wight Gallery, Los Angeles, CA

1993

December to January 1994—Asian Roots, Western Soil, Berkeley Art Center, Berkeley, CA

1994

January to March—The View from Within travels to the San Jose Museum of Art, San Jose, CA. During *July to August* the exhibit travels to the Salt Lake City Art Center, Salt Lake City, UT. In *September to October* it travels to the Honolulu Academy of the Arts, Honolulu, HI.

1995

During *May to July, The View from Within* travels to the Queens Museum of Art, Queens, NY.

September to October—With New Eyes: Towards an Asian American Art History, San Francisco State University Art Gallery, San Francisco, CA

August to October—Japanese and Japanese American Painters in the United States, A Half Century of Hope

and Suffering, 1896–1995 in conjunction with the Japanese American National Museum, Tokyo Metropolitan Teien Art Museum, Tokyo, Japan. During *October to November* the above exhibit travels to the Oita Prefectural Art Hall, Oita City, Japan. In *November to January, 1996,* it travels to the Hiroshima Museum of Art, Hiroshima, Japan.

1997
March—Asian Traditions/Modern Expressions: Asian American Artists and Abstraction 1945–1970, Zimmerli Art Gallery, Rutgers University, Newark, NJ. During *April to June* the exhibit travels to the Bedford Gallery, Dean Lesher Regional Center for the Arts, Walnut Creek, CA.

July to January 1998—Art of the Americas, Part III, Identity Crisis, M. H. de Young Museum, San Francisco, CA

1998
February to March—Unthinkable Tenderness, The Art of Human Rights, San Francisco State University Art Gallery, San Francisco, CA

1999
March to May—7 lb. 9 oz.: The Reintegration of Tradition into Contemporary Art, The Asian American Arts Centre, New York, NY

2000
March to June—America's Concentration Camps: Remembering the Japanese American Experience, California Historical Society, San Francisco, CA

October to March 2001—Made in California: Art, Image, and Identity 1900–2000, Los Angeles County Museum of Art, Los Angeles, CA

HONORS

1979
May—Hisako Hibi was featured as an Issei fine artist on the nationally syndicated television program *Over Easy* with host Hugh Downs.

1985
July—1985 recipient of Award of Honor in Painting by San Francisco Arts Commission, Fairmont Hotel, San Francisco, CA

1994
CD jacket cover of *Earth Prayer,* six musical compositions by jazz musician and taiko master Russel Baba

Hibi *mon* (crest) is included in the permanent bronze sculpture by Ruth Asawa in remembrance of the Japanese American internment experience and artists at the Federal Building Plaza, San Jose, CA.

1995
May—Hisako Hibi paintings are included in *The New Americans: Tanforan,* PBS television documentary produced by Diane Fukami, San Mateo, CA.

May—Hisako Hibi paintings are shown in conjunction with eight musical compositions by Russel Baba, played on stage at the Asian American Jazz Festival, Asian Art Museum, San Francisco, CA.

1997
February—Hisako Hibi paintings are shown along with the Russel Baba and Jeanne Mercer jazz concert at the Brown Trout Gallery, Dunsmire, CA.

BIBLIOGRAPHY

Albright, Thomas. *Art in the San Francisco Bay Area 1945–1980, An Illustrated History.* Berkeley and Los Angeles: University of California Press, 1985

Barron, Stephanie, et al. *Made in California: Art, Image, and Identity, 1900–2000.* Exhibition catalog. Berkeley, Los Angeles, and London: University of California Press and Los Angeles County Museum of Art, 2000

Brown, Michael D. *Views from Asian California 1920–1965, An Illustrated History.* San Francisco: Michael Brown, 1992

Fuller, Diana Burgess, and Daniela Salvione. *Art/Women/California, Parallels and Intersections, 1950–2000.* Berkeley, Los Angeles, and London: University of California Press in association with the San Jose Museum of Art, 2002

Gesensway, Deborah, and Mindy Roseman. *Beyond Words: Images from America's Concentration Camps.* Ithaca, New York: Cornell University Press, 1987

Higa, Karin, et al. *The View from Within: Japanese American Art from the Internment Camps, 1943–1945.* Exhibition catalog. Los Angeles: Japanese American National Museum, 1992

Hill, Kimi Kodani. *Topaz Moon: Chiura Obata's Art of the Internment.* Berkeley: Heyday Books, 2000

Niiya, Brian. *Encyclopedia of Japanese American History, Updated Edition, An A-to-Z Reference from 1868 to the Present.* Los Angeles: Japanese American National Museum, 2001

Wechsler, Jeffrey. *Asian Traditions, Modern Expressions, Asian American Artists and Abstraction 1945–1970.* New York: Harry N. Abrams, Inc., in association with the Jane Voorhees Zimmerli Art Museum, Rutgers, The State University of New Jersey, 1997

CONTRIBUTING ORGANIZATIONS

Peaceful Painter accompanies a retrospective exhibition of the works of artist Hisako Hibi presented in fall 2004 at the de Saisset Museum at Santa Clara University. *Peaceful Painter* is a collaborative effort between the following organizations on the impact of the World War II incarceration of Japanese Americans:

California Civil Liberties Public Education Project (CCLPEP)
P.O. Box 942837, Sacramento, CA 94237-0001
www.library.ca.gov/cclpep/index.cfm

de Saisset Museum
500 El Camino Real, Santa Clara, CA 95053-0550
www.scu.edu/deSaisset

Heyday Books
P.O. Box 9145, Berkeley, CA 94709
www.heydaybooks.com

Japanese American National Museum
369 East First Street, Los Angeles, CA 90012
www.janm.org

San Francisco State University
1600 Holloway Dr., San Francisco, CA 94132
www.sfsu.edu